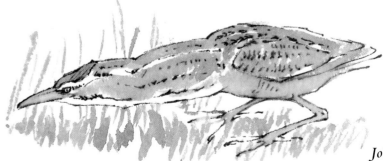
John Busby: Bittern.

DRAWING BIRDS
John Busby

An RSPB Guide

To the memory of two Erics:
my father, Eric Busby, for the inspiration of his
life and faith, and Dr Eric Ennion, who taught so
many to see and draw birds.

Published by The Royal Society for the
Protection of Birds, The Lodge, Sandy,
Bedfordshire SG19 2DL

Designed by Patsy Hinchliffe

Typesetting by Bedford Typesetters Ltd
Origination by Saxon Photolitho Ltd
Printed by David Green Printers Ltd

ISBN No 0 903138 21–2

DRAWING BIRDS
John Busby

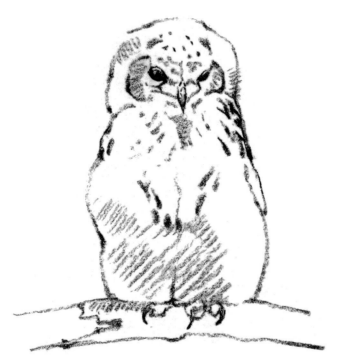

John Busby: Young eagle owl.

An RSPB Guide

Acknowledgements

First of all my thanks go to all the artists who have lent work for this book, and for their trusting enthusiasm for a project they had not seen in advance. I must emphasise that inclusion in this book does not necessarily mean that the artist agrees with everything I say; there are thankfully many views on art.

My thanks also to those who lent paintings from their collections: to Robert Gillmor and Chloe Talbot Kelly for the paintings by R B Talbot Kelly, and to Hugh Ennion for his father's work. For permission to reproduce I should like to thank The Burrell Collection, Glasgow, for Joseph Crawhall's *The Pigeon*; The Bodley Head for J A Shepherd's drawings from *The Bodley Head Natural History*; Abydos Fine Art for the *Grey Starling with Loquat [1789]* by Kitao Masayoshi, from the Chester Beatty Library and Gallery of Oriental Art, Dublin; the trustees of the Tunnicliffe estate for the two studies by this artist. 'Common Grounds', have given enthusiastic permission for me to quote from David Measures' article in *Second Nature* published by Jonathan Cape. The Thielska Gallery, Stockholm gave permission to reproduce the *Black-throated Divers* by Bruno Liljefors.

The whole idea owes much to Sylvia Sullivan of the RSPB, at whose suggestion a pilot series of articles was first published in *Birds*, and who has guided this book through all its stages.

Finally, my thanks to my wife Joan, who against my better judgement bought a word processor, which proved, like herself, to be a godsend.

Contents

John Busby: Long-tailed tit.

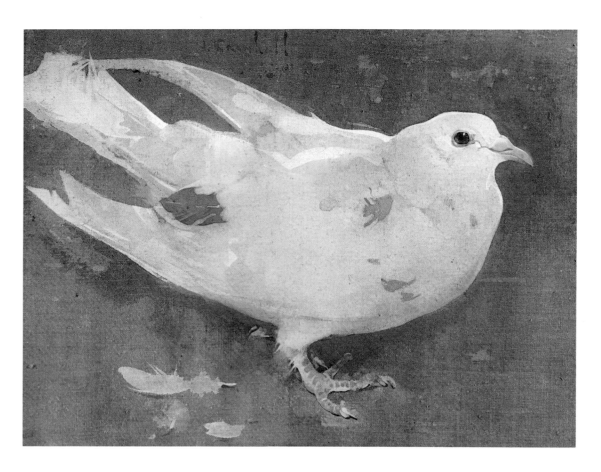

Joseph Crawhall: 'The Pigeon'; a gouache on Holland cloth. (The Burrell Collection, Glasgow Museum and Art Galleries).

Chinese artists practised the painting of nature from memory after acute observation. This was regarded as one of the highest expressions of the depth and subtlety of the human mind. Crawhall, like many of his friends in the 'Glasgow School' at the turn of the century, was influenced by the freshly discovered art of the Far East, and he had been taught as a boy to draw from memory. Crawhall's birds, horses and other animals are conceived in a similar spirit to the Chinese, and achieve great beauty and unity of subject and thought.

1: Birds in the Mind

THROUGHOUT the ages, whenever artists have made images from nature, birds have caught the imagination and inspired a creative response. They are seen as both beautiful and sinister; glorious in plumage, but hard of eye and wild of spirit; as a quarry to be hunted for food, and as inhabitants of the world of air beyond human reach. They have been made into the likenesses of gods, and fashioned into heraldic and national emblems of power. Even the invisible forces of good and evil have been given form as white dove and night-backed raven. In themselves they are beautiful in form and movement, and so superbly decorative that they have been used as motifs on all manner of ornament from pottery to postage stamps, tapestry to tableware all over the world.

There is almost limitless scope for artists to use birds – real or imaginary – as decoration. Plumage pattern is one of the richest veins in all nature, yet it is often plundered tastelessly. The best decorative pictures of birds are those which manage to combine the plumage details we so enjoy, while retaining the liveliness that is so much of the charm of birds.

To the artists of the Far East, painting was an act of celebration as well as decoration. Peacock, pigeon, finch or crane were given a rhythmic grace and energy to match their character and keep them in harmony with their surroundings. Western artists seem to prefer to hold their birds captive in static poses, where a bird can be painted to show off its plumage to best advantage, and to display a knowledge of species classification. The early scientist/artists who began this trend towards accurate rather than freely artistic birds, had an objective purpose which over-rode aesthetic considerations – the recording of the world's species. Not without some artistry, they faithfully recorded every detail of a bird's plumage. Although the drawings are often naïve or quaint, and owe most to a dead specimen, the etching process and subsequent hand-colouring gave these early book-plates an attractive clarity lost to many modern illustrations.

Classification is now no longer the main motive for bird painting, yet the definitive study has come to dominate our ideas of bird portraiture to such an extent that an artist can be trapped creatively by the sheer weight of known facts by which he thinks the 'rightness' of a picture will be judged. Correctness can become an obsession, and in some pictures one can imagine the artist ticking off a strict check-list of detail to be included before a bird can be considered finished. This is a formidable inhibition; one that can make a beginner doubt his or her own observation and suppress creative feelings.

The idealised portrait one sees so often in modern coffee-table books is really a hybrid between a scientific study and popular, decorative images of birds. The resulting birds look more often like paintings of porcelain figures, complete with a tasteful spray of appropriate flowers: any real experience lost to convention. Just as we like flattery in human portraits, so we like perfection in nature. The honesty of a Rembrandt in the world of bird art might be more difficult to live with.

Some would maintain that feeling should have no place in nature painting, which in order to be truthful should be entirely objective; free from expression of any kind. This is to confuse two kinds of truth – one made up of facts we measure and record, and the other revealed

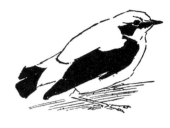

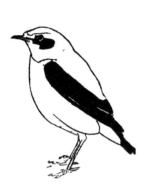

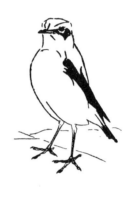

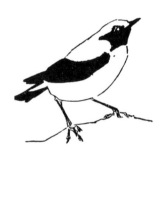

*J A Shepherd: Line drawings of wheatears
(Vol 1 of the Bodley Head Natural History,
1913).*

*J A Shepherd was a master of line, and
had a cartoonist's eye for character and a
delight in his subjects; his drawings speak
volumes about the ways of birds and
animals. A* Guardian *critic at the time the
book was published hoped that it would
inaugurate a new era. In illustration this has
been a long time coming, but Shepherd's
influence can be seen in the work of
R B Talbot Kelly and E A R Ennion, and I
freely acknowledge it in my own. Though three
volumes of birds were planned in this series,
only the first two were published, together
within a single binding.*

through the interpretation of our experience of reality. There is a creative objectivity which can show itself in other ways: a 'return to nature', expressed as a break with artistic conventions, changing the way we see or think about a subject. Many revolutions in the world of art began like this, turning a fresh, more truthful eye on the world. Both Audubon in America and Liljefors in Sweden changed the way artists look at nature. Can one say that either were objective in their approach? Audubon broke the mould of current ornithological illustration and gave it a new, passionate intensity which is striking even today. His attention to detail was objective enough, but the resulting energy and individuality of his work is anything but. Liljefors, though less revolutionary in style, brought a new objectivity to the concept of portraying nature – he painted what he saw and only what he saw, devoting himself to hours of watching birds and animals in the wild, not posing, but being themselves. There is a breathless sense of 'being there' about his work. He handled paint with mastery that Rubens would have admired, responding brilliantly to textures (the fur of a fox); to movement (winds and birds among fir trees); and to infinitely subtle qualities of light and times of day, with all the instinct of a great conductor for the balance of every orchestral detail. However objective in intention, his work is a powerful and optimistic testimony to man's relationship with nature – a deep-felt love without a trace of sentimentality.

Today, especially in America, we see a devotion to a new ultra-realism, where bird and background are rendered, sometimes dramatically, but with an indiscriminate objectivity. Every last detail is studied, checked for authenticity, and painstakingly re-created. The skill involved is impressive, but the subservience of cohesive pictorial thought to a saturation of visual facts is not, to my mind, the business of art, and the effect is often so contrary to the way we perceive anything in nature, that the much sought-after authenticity is lost.

One of the strongest influences on the way birdwatchers see birds today is that of the 'field guide' illustration. These guides, where species are placed side by side for comparison of scale and plumage, are invaluable in teaching identification skills. They are a ready reference for the diagnostic features of each species. When I was a boy no such books existed, and learning the look of unfamiliar birds had to be gleaned from direct experience, perhaps with the help of a friendly expert. I remember making my own wall-chart of British birds to help to fix their characteristics in my mind. Field guides by their nature present a stereotyped picture of an average bird, which of course does not exist. Nor does the stiff side-view image readily match the individual bird you meet in the wild. Too many popular guides are superficially drawn and inaccurate, particularly in the shape of a bird. More specialised guides tend to be better as they cater for more knowledgeable birdwatchers.

Some guides manage to show the character of a bird through its posture, but these are rare. J A Shepherd did this most tellingly with line only in the Bodley Head Natural History volumes in 1913, and recently the Penguin Field Guides of Lars Jonsson show how much the 'jizz' of a bird aids its identification. They also show how artistic discernment in the handling of detail helps one to see.

Field guides can actually hinder our personal observation by giving an identity-kit substitute for the real thing. We may need to discard these images once identification ceases to be a normal problem, before we can see birds with any degree of originality. Most people's mental images of birds are probably influenced by book illustrations, but I think that the painters, or painter/illustrators, have been the main innovators of bird art. One thinks of the

◀ *Chloe Talbot Kelly: Hoopoe; watercolour.*
A painting exploiting the marvellous potential for shape and pattern in such an ornate bird, and creating equal beauty in the 'negative' spaces around: delicate, accurate, and unashamedly decorative.

▶ *R B Talbot Kelly: Lapwing and chicks; watercolour.*
A fine watercolour of a living, anxious bird, poised for flight. The fluid nature of the drawing unifies both the birds and the background, which gives a spaciousness to the painting. The bird's tense and watchful eye holds your own.

▼ *Bruno Liljefors: (1860-1939).*
Black-throated divers, 1901; Thielska Gallery, Stockholm.
Birds, sea, light and wind — all the elements of the experience of the moment — are unified by the artist's masterly composition. Nothing is left to unconsidered chance; every note of colour, every shape and brush-stroke, is eloquent and meaningful, creating a personal vision that is universally true in both fact and feeling.

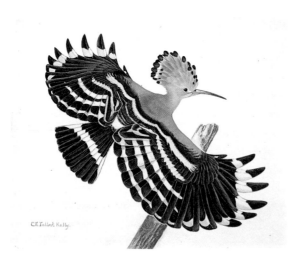

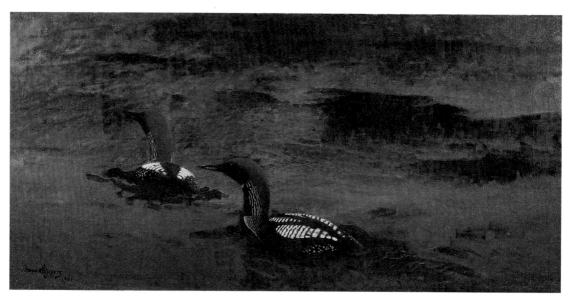

Renaissance masters – Pisanello and Carpaccio, and the flight studies of Leonardo; the Dutch painters of domestic and menagerie birds; Liljefors, a strong influence on Scandinavian artists; Thorburn, his exact contemporary in Britain; Joseph Wolf before Thorburn; Sir Peter Scott and Charles Tunnicliffe since; Fuertes and the Thayer brothers in America, predecessors of the new generation of wildlife artists.

A painter I hold in great esteem, though less well known, is Joseph Crawhall, who was associated with the 'Glasgow School' at the turn of the century. Crawhall's work combines superb draughtsmanship and composition with strong feeling for the inner life of his subjects. His birds are mainly domestic – cocks, ducks and tame jackdaws. His picture 'The Pigeon' (see page 8), now in the Burrell Collection in Glasgow, is a masterpiece – one of the most alive birds I have ever encountered in painting.

Birds appear only rarely as themes of modern artists. Picasso's lithographs of owls and doves are beautifully drawn, strongly evocative and overlaid with symbolic meaning. The painter Braque and the sculptor Brancusi used bird motifs all their lives – highly personal symbols that refined the spirit of birds and flight. Light-hearted birds can be found in the paintings of the modern American artist Milton Avery, and rather sinister ones in the drawings and sculptures of Elizabeth Frink.

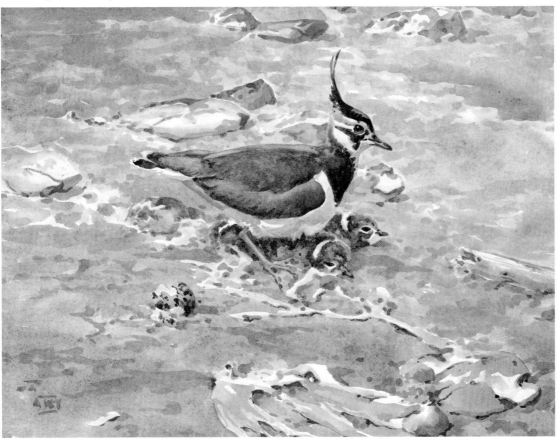

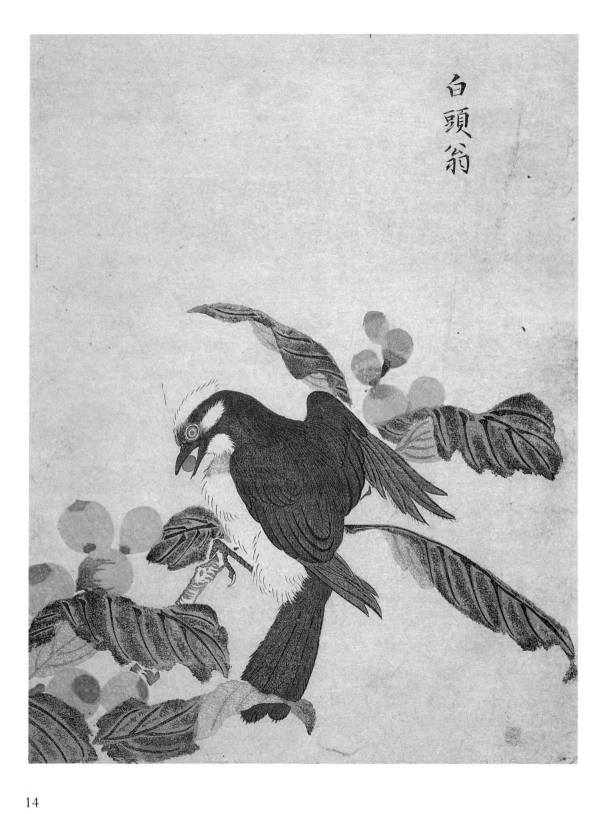

白頭翁

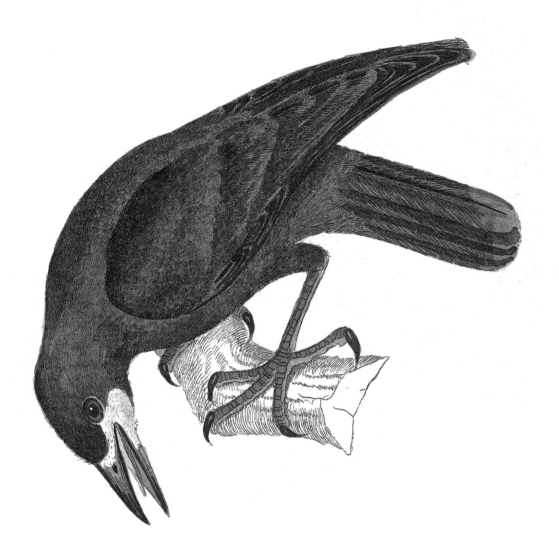

◀ *Kitao Masayoshi; Grey starling with Loquat, 1789.*

From a Japanese woodblock printed book called Pictures of imported birds *in the Chester Beatty Library and Gallery of Oriental Art.*

▲ *An early ornithological book illustration; hand-coloured copper engraving.*

A rook from Wm Lewin's Birds of Great Britain *1789-94. The bird is unusually active for its time, but the conventional fragment of twig goes back to the earliest 16th century illustrations. No attempts are made to set the scale of the bird in natural surroundings.*

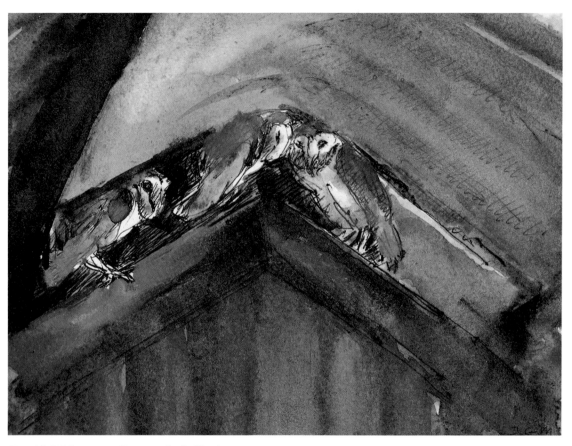

David G Measures: Barn owls; ballpoint pen, fingers and watercolour.

These owls are retreating as far as possible from intrusive human presence, into the roof of the cattle-feed loft.

David Measures always sees the life of his subjects in relation to their environment, and his paintings are charged with the intensity of his own response. The painting thus has an immediacy which he believes is impossible to re-create in a studio.

16

Too many wildlife artists shut their eyes to the values of the wider world of art, and then complain that their own work, which may ignore the aesthetic and emotional energies that are the lifeblood of art, is not admitted into the same league. Knowledge of subject matter alone is not enough. Art is a synthesis, a unity of the ideas and the means used to express them. There has to be a pictorial reason for the relationships which are made between shapes and spaces, lights and darks, colours, rhythms of line. Everything that controls the movement of the eye as a picture is read. These forces only come together in a work of art. They do not exist in nature in the same kind of relationships. In a picture they are governed by the artist's choice. One cannot draw or paint 'what one sees', and be blind to what is happening on the page or canvas in the process. However fascinating the subject matter, there needs to be an equal fascination with the whole business of making marks with which, in a childlike way, one can identify. To copy nature without resolving one's own thoughts and feelings is a barren experience.

Openness to the wider world of art is as essential to growth in pictorial imagination, as reference to living birds is to the understanding of your subject matter. There are those alas who can enjoy the birds of Gould or Fuertes but do not respond to those of Braque; who see only horses in Stubbs, and feathers in Audubon. Images from the past are fine if we can build something new and vital from them. My rather severe impression is that there is too little vitality in much current and past bird art. If this is so, then the need on one hand is to 'go back to nature', and on the other to study art more openly.

The choice facing those who aspire to draw and paint birds today is whether to rely on past images, and copy accepted styles of conventional wildlife art, or to go direct to nature and respond to living birds. My choice was made long ago when in my early teens an enlightened great aunt gave me a copy of R B Talbot Kelly's *The Way of Birds*. This artist and Allen W Seaby, who painted most of the plates for Kirkman and Jordain's *British Birds*, (reprinted in time for my sixteenth birthday), opened a window to reality after the stuffy plates of my earlier bird books.

This book is for those who want to portray living birds. It is a book about drawing, the most immediate and fundamental language of artists in any medium. Throughout I have used examples by artists who work from life, showing many drawings made on the spot with no particular end product in mind, and which show most clearly the working thoughts of the artists. Some of the artists have been practising for years; others are just beginning. I hope our vision of birds reflects the freshness and some of the excitement of our experiences, and that I have been able to pass on enough helpful practical advice to encourage those who also draw from nature.

Even without aspirations to draw, I hope you will find here fresh ways of looking at birds, and some new insights into their meaning in art.

Eric Ennion: A zoo study of a blue eared-pheasant.

Soft pencil used in clear, direct lines. Ennion liked to draw on large sheets of paper when at a zoo, so that his hand could move freely from the wrist. The lines have a strong rhythmic relationship giving movement to the bird – there is no fussing, and not a line too many.

2: Birds in the Eye

IT is tempting to think that drawing can be taught methodically to a set of rules. Over the years of teaching at an art college I know that despite my advice and stage-managed exercises, the students have largely taught themselves (with a little encouragement from me) through much practice and experiment, the exercise of imagination and a willingness to take risks. It is a process of trial and error, and one can learn as much from mistakes as by occasions when everything goes right.

Drawing taught to rule seldom produces anything with real vision behind it. Some rules may help initially (regarding perspective for instance). However, whereas copying the outward form of things is largely a matter of common visual sense which many people with a good 'eye' can pick up, to transform that into art there needs to be a creative engagement of the inner 'eye' of each individual artist's understanding. There are no rules governing the emphasis an artist may choose to put on something, or what to leave unsaid. The 'tone of voice' of a drawing will be different for every artist, and may convey more than the 'words' spoken.

A drawing can be made as an end in itself, or as a means to an end. As a work of art it should be satisfying aesthetically through the skill and dexterity of handling; in the economy and balance of the design – and at the same time revealing the artist's insight into the subject of the drawing – form and content linked together. But as a tool for learning, that need not be its primary purpose. It would hardly matter whether such a drawing were beautiful or not, so long as it was a visual aid – to help fix things in the memory perhaps.

Most of us will at some time have scribbled a sketch-map to guide a visitor, or a diagram to show someone what we have in mind for a particular project. A drawing can be a quick reminder of some event – an addition to a letter or a diary, or a nature note-book. My father always laced his letters with matchstick men enacting encounters with the neighbours – highly graphic and humorous drawings using very few lines. It is amazing how quickly the eye will pick up meaning in the barest suggestion. A few straight lines can become a tree or a building; a circle can turn into a wheel, the sun, or a person's head. The old cliché for a flying seagull is instantly recognised; and everyone can draw that! Inventing one's own expressive shorthand can be a good first step towards more sophisticated drawing.

Encounters with wild birds and animals are usually measured in split-seconds, and one is rarely given another chance to react, so a high-speed response is worth cultivating. Latching on to what is important comes with experience, but even if you 'can't draw' in the art college sense, there is much that can be done to sharpen observation and fix events in your memory.

Many naturalists keep field journals, augmenting written notes with sketches and diagrams, and most would agree that notes made at the time are the only truly reliable ones. So it is with drawings. When in the field forget the finished picture and record what you see as simply and directly as you can.

The first step is to 'be prepared'. I actually see more to record if I leave the house with a sketchbook in my hand and a pencil behind my ear (not literally), than I do if the means of drawing are packed away out of sight. A pocket-sized note- or sketchbook will suffice. Use

20

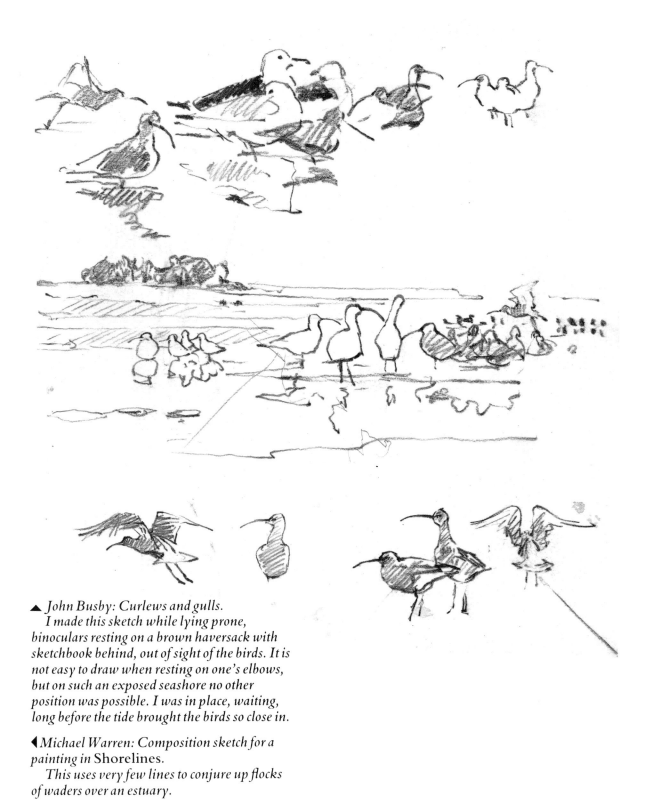

▲ *John Busby: Curlews and gulls.*
 *I made this sketch while lying prone,
binoculars resting on a brown haversack with
sketchbook behind, out of sight of the birds. It is
not easy to draw when resting on one's elbows,
but on such an exposed seashore no other
position was possible. I was in place, waiting,
long before the tide brought the birds so close in.*

◀*Michael Warren: Composition sketch for a
painting in* Shorelines.
 *This uses very few lines to conjure up flocks
of waders over an estuary.*

21

John Paige: Sketches of eiders.

Richard Kemp: Brent geese.
 A brush drawing; quicker than any other medium if ready to hand, as one can both draw and fill in shapes simultaneously. The massed bodies of the geese are unified with a single, dark colour, throwing the heads into silhouette.

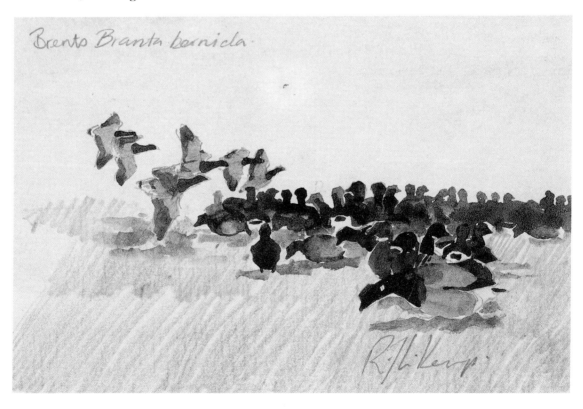

bound paper so that sheets do not tear off and blow away, tinted perhaps to avoid the sudden exposure of a white page to nervous birds, and with an inconspicuous, hard-back cover, as waterproof as possible. Used pages can be held down by an elastic band so that the book opens without flapping, ready for action.

It is sometimes suggested that for drawing purposes birds are basically egg-shaped with a smaller egg for the head. This may be helpful when drawing a static side-view bird, but is rather an applied formula, and as birds can change their shape in a twinkling, I find it better to begin with some indication of what it is doing. If you are watching a bird's behaviour, there is no need for a detailed study of the bird; what it is doing or where it is going will be more important, and this can be suggested sometimes by just using directional lines and arrows – more a diagram than a drawing. It may help if you can 'see' invisible lines – one for instance which represents the axis through the body. Most shapes (except squares and circles) have a dominant axis, and a bird's body can easily be seen to be level or tilted. It does not twist and bend like a mammal's body, so the axis remains straight and pivots on the angles of the legs. Movement can be suggested by the way these angles, with those of the head and wings relate to each other.

A bird uses its bill for most of its actions on land. If it is feeding, the action begins with the thrust of the bill, and its body is balanced to make this possible. There is a tension running through the bird affecting its outer shape – miss that and your bird will show only the appetite of a museum specimen. Preening is also concentrated in the activity of the bill reaching to all parts of the body, but there is a relaxation in the body feathers. The important thing to look for is balance. This is something you can sense far more by watching a living bird than ever you can from a still photograph. Sometimes I have found it useful when looking at a mixed group of active waders, for instance, to concentrate, not on the different species, but on as many aspects of balance as I can find.

If groupings of birds are of interest to an artist, then the spaces between them may matter most, and the birds can be represented merely by a series of blobs – a kind of visual algebra.

John Busby: Just a few lines and blobs – or? –
waders and rocks, and a passing heron!

John Busby: A drawing can quickly show the difference between a coot swimming towards a rival and a nearby group of resting wigeon.

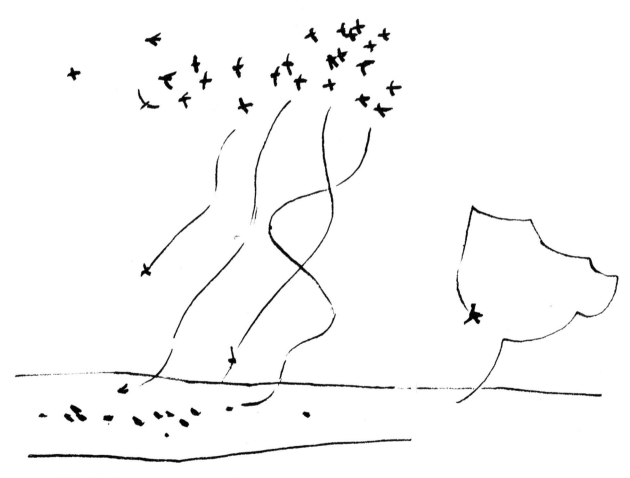

John Busby: Lines can indicate flight paths or the tumbling fall of rooks descending to feed.

John Busby: Lines representing water will flow more strongly when the resistant shape of a rock is introduced. Contrasting shapes or directions of movement make each more apparent.

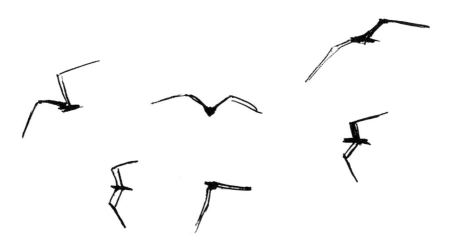

John Busby: 'Shorthand' for a flying seagull – instantly recognisable. Drawing a flock of birds like this from memory can lead to many discoveries of patterns for pictures.

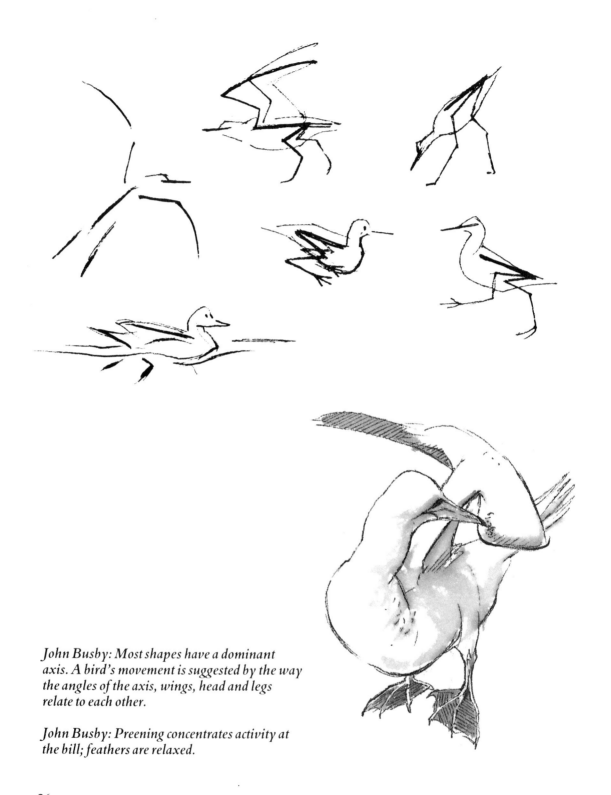

John Busby: Most shapes have a dominant axis. A bird's movement is suggested by the way the angles of the axis, wings, head and legs relate to each other.

John Busby: Preening concentrates activity at the bill; feathers are relaxed.

26

Instead of a complicated drawing of every bird, try small blobs for dunlin or ducks and larger ones for curlew or geese. With such means you can calculate great spatial equations, and portray the whole bird distribution of an estuary. Whatever it may look like to anyone else, your drawing can remind you of what the birds were doing, about the shapes of their groups, about distances and the scale of the environment – about the pattern of it all.

It is not too difficult to show the scale of one object to another; the point is made by contrast. Similarly, contrasting shapes or directions of movement make each more apparent. Water, for instance, will flow more strongly if a resistant rock is introduced into the drawing. A drawing could show quickly the difference in purpose between a coot swimming towards a rival, and a nearby group of resting wigeon, where it would take a good many words to do so. With the addition of arrows, the direction of wind or sunlight can be indicated.

Less overtly visual things, such as the flight path of a displaying lapwing, or the tumbling fall of rooks descending to feed, could be tracked with a series of lines. A sequence of such drawings could record a chain of events.

Draw with whatever moves quickly over the paper. I prefer either a fine-pointed black pen (of which there are many makes on the market – Faber Fine-point, Hellerman Penstick, and Edding 1800 are among those with varying grades of fineness) or a sharp but soft pencil – 3 to 6B. (A pencil sharpener is a must, and I use mine as frequently as a snooker player uses chalk.) David Measures uses a child's multicoloured biro to great effect, smudging the colours with a licked finger. Some felt-tipped pens run slightly when a wash is added, giving a bluish colour. With a warm sepia wash on the brush picking up this cooler colour, one can lay in the warm and cold areas of colour in one go. (More about that later.) When drawing in the field it is better to suspend judgement and keep going, rather than to worry about the quality of your work. Often there is only time for a few lines, a reminder of some action. To attempt a bird portrait on the first encounter is fatal, and one should be prepared for months and even years of acclimatisation.

Killian Mullarney says that he often sees young and enthusiastic observers poised over their telescopes with notebook on knees, pencil in one hand and rubber in the other, trying hard to complete a portrait, but every movement of the bird causes them to erase more than they put down.

"I know exactly how frustrating this can be," he goes on, "because I did it for years. Suggesting that they work quickly is of little use, because they often lack sufficient understanding of their subject to draw quickly. What I have advised, and it seems to help, is that they devote the first half-hour to learning and, rather than attempt a bill to tail drawing straight away, draw parts of the bird as they see them. They may end up with a page or two of bits and pieces, but if they *then* attempt an overall sketch it is likely to come more easily." This is sound advice.

Drawing is a way of learning to see. Draw anything and you will know it far better than before, even if the drawing is not up to much. You also begin to realise that your eyes are giving you contrary information all the time. What you see after three minutes' drawing will be quite different from your immediate impressions, and from your understanding half an hour later, when your eyes have travelled over, through, and around the object of your drawing many times. Drawing is like the unravelling of a mystery – a search for the true nature and meaning of an object. Such drawing, which seldom sees the light of day outside the

27

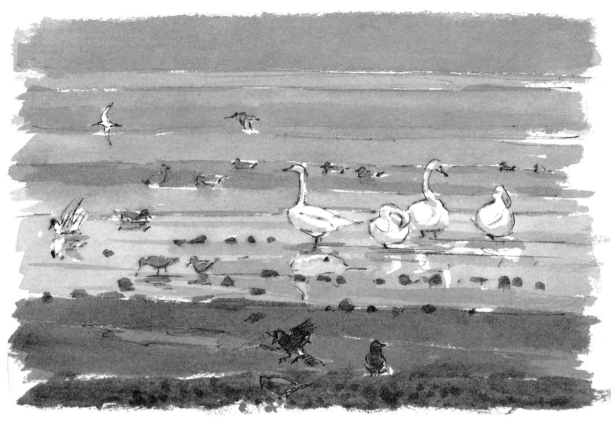

John Busby: Whooper swans, waders and
starlings, at Aberlady Bay; low tide.
 Two shoreline movements drawn with a
black, fine-pointed pen with watercolour added
on the spot, taking on some tints from the ink.

artist's studio, can be far more exciting to read than a carefully finished painting, where the processes of creation are no longer visible. The sketchbooks of Leonardo, of Constable, Braque, Andy Wyeth, Henry Moore, or of Fuertes or Tunnicliffe, are rightly prized for the light they shed on the artist's thoughts in the search for expression.

 Art students have found it difficult enough to come to terms with what used to be called in my student days, the 'significant form' of a still-life, or of a model sitting still for hours, without having to cope with a subject that prefers to be out of eye-shot, so be patient. It may take years of practice to discover enough about the ways of birds and the ways of drawing to bring both together with conviction. Even slow-moving birds are not easy to see and retain in the memory for long, and you may end up with pages of barely recognisable fragments.

 Initially one is learning to react quickly, to free your hand to respond before the brain has time to think – 'that's not right'. Use drawing primarily as a means of finding out more about nature. Artistic results will be less important at first, though working quickly develops a sense of pictorial balance and energy which will not be wasted later.

John Busby: Blobs become a kind of visual algebra to indicate distributions.

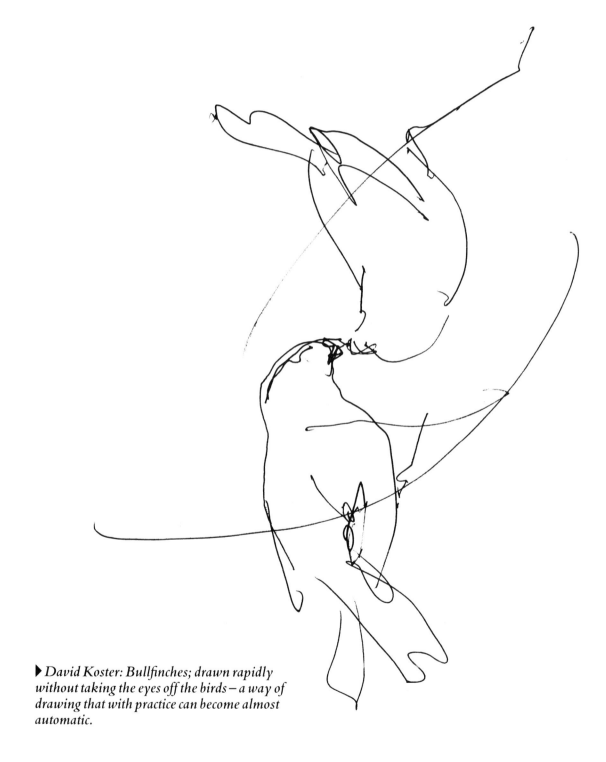

▶ *David Koster: Bullfinches; drawn rapidly without taking the eyes off the birds – a way of drawing that with practice can become almost automatic.*

Janet Melrose: Young snowy owls; Edinburgh Zoo.

The artist visited the growing family many times, filling more than one sketchbook with drawings of the young at all stages. The young owls wear a 'Balaclava helmet' of grey and have an engaging habit of resting with their necks stretched out along the ground.

Felt-tip pen using the side rather than the point, and a very light touch in the shading. A packed page of drawings, sometimes overlapping, generates its own momentum rather like film animation.

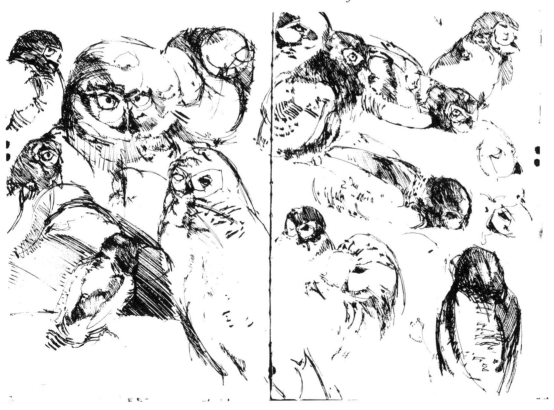

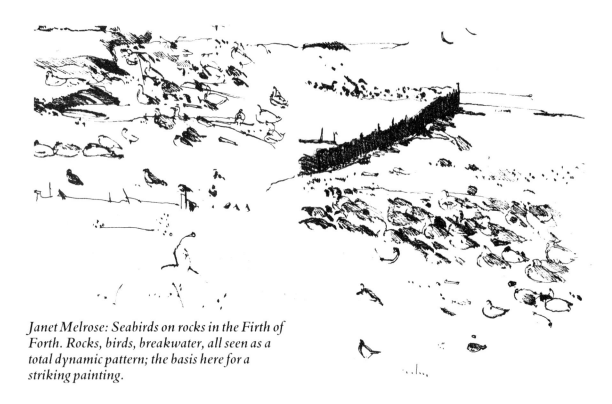

Janet Melrose: Seabirds on rocks in the Firth of Forth. Rocks, birds, breakwater, all seen as a total dynamic pattern; the basis here for a striking painting.

Ink is a good learning medium because it is committed. You cannot rub out, though you can overrule with even blacker lines. Also, a pen moves more quickly than a pencil. A black ink line is so unlike the actual edges of whatever you are looking at, that it is easier to understand that drawing is a translation from one reality (that of the bird), to another (that of the drawing). The 16th century artist Cennino Cennini, who was a pupil of a pupil of the great Giotto, wrote a delightful treatise on artists' methods. On the value of ink drawing, he said, "Do you know what will happen if you practise drawing with a pen? It will make you expert, skilful, and capable of much drawing out of your own head."★

I find a soft pencil equally good, as I can put in 'instant sunshine', that is to say, shading, which of course is the way to draw light. Sometimes blocks of shading can go down before one has time to pull the forms together with line. This is particularly useful in dealing with rocky or landscape backgrounds.

It takes rather more courage to start off a drawing using a brush and washes of ink or watercolour. A brush cannot emphasise a line by increased pressure as can a pencil, but it can freely cross over boundary lines of shapes and unify areas of colour or tone. This is a medium to use from a sitting, relaxed vantage point, perhaps a park lakeside, where there is time to prepare and a flat space to keep your water jar steady. It is a medium for blocking-in the potential pattern of a picture, about which, more anon.

★Cennino Cennini; *Libro del Arte*, translated by Daniel V Thompson (Constable & Co).

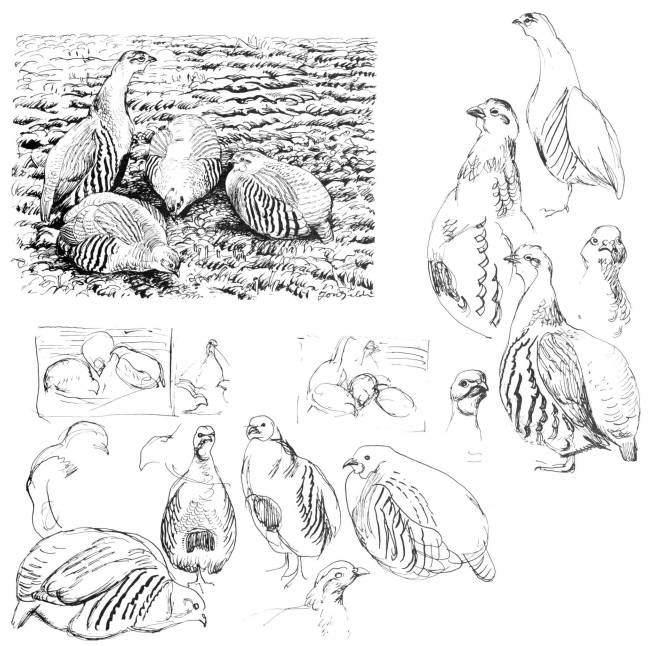

Jon Fjeldså: Pen drawings of common partridges, with sketches towards a grouping suitable for an illustration.

Fjeldså is an ornithologist who uses a great deal of drawing in his field work. Accuracy is of the greatest importance in his studies of the development of plumage. He also retains a delightful ability to simplify essentials and to give life to his birds: an example of specialised knowledge liberating artistic expression rather than cramping it.

*Peter Partington: Pencil sketch of starlings on
the back of a pig.*

*David G Measures: A line of Sandwich terns
resting and preening as the tide recedes at
Thornham: biro and wash.*

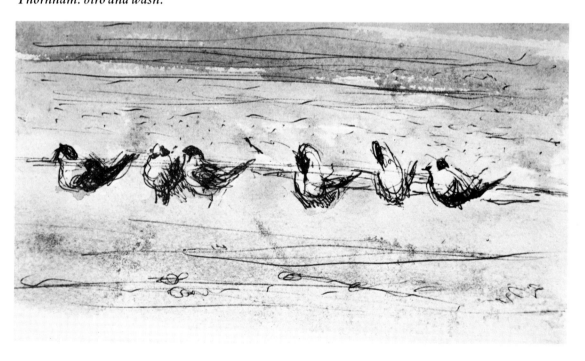

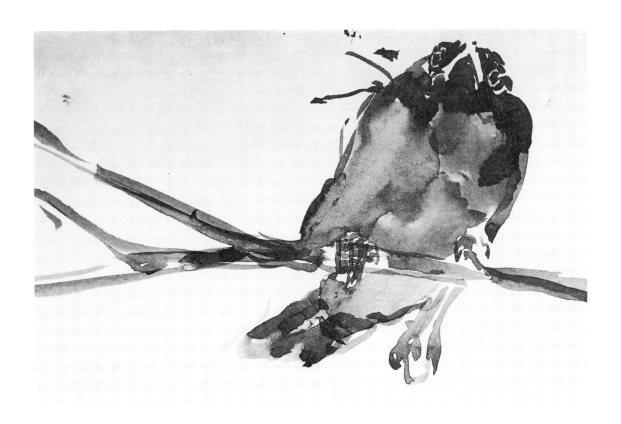

David G Measures: Crow fledgling.
 *"The third nestling launches out and glides
rather than flies to the next tree and balances
awkwardly." A brush drawing in grey and
black watercolour – immediate and whole – the
washes of paint becoming the bird in the curious
alchemy of art.*

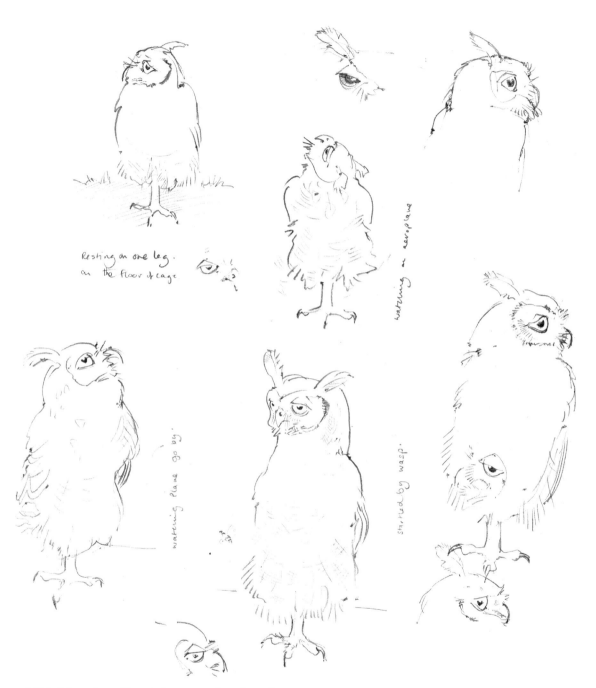

Resting on one leg.
on the floor of cage

watching an aeroplane

watching plane go by.

startled by wasp.

*Mick Manning: Abyssinian spotted eagle owl,
London Zoo, startled by a wasp and watching
an aeroplane, the artist responding to the
humour of the situation.*

3: Birds in the Hand

IN the previous section I suggested ways of developing a quick drawing response to what you see without first acquiring a highly specialised knowledge of the birds you are watching – that can grow with experience.

I stressed behaviour as the key to drawing with understanding, beginning with birds you know from life and can watch without difficulty.

I have seen it argued that because the physical features of, say, a sparrow are so well documented, any drawing of the same must conform to that knowledge. If this stricture takes no account of the great diversity in the way people perceive things, to say nothing of changing light and backgrounds, or that no two sparrows are identical in every way, it is a creative death sentence. I am not suggesting that it is more artistic to get the sparrow wrong, but it is the function of an artist to open people's eyes to what has not been seen before, and I firmly believe, to express a human response to it.

However, a quick drawing reaction to what one sees is easier if there is knowledge to back it up. As your experience of birds grows, you will more easily recognise important variations in behaviour from the norm, and an understanding of the basic anatomical relationships within a bird's body is necessary in order to raise the level of your drawing and to give confidence to tackle the unusual.

In some ways a bird is a simple form compared to a mammal. Most of its bones and muscles are out of sight behind feathers, and there are not so many differences in form within the range of bird species as there are among other animals. But birds can change their outer shape disconcertingly at times either by fluffing out their feathers or pulling them in tight to the body, and flight produces a greater range of movement and angles of view than one is likely to see in most animals.

In detail, the bones of the body need not concern the artist, though they are as fascinating as those of any other creature; light and finely moulded for strength. Pelvis and back vertebrae are fused into an almost rigid structure to give greater strength for flight and to help the bird to balance on two legs. These hidden bones can be sensed by a single axis line as I suggested earlier, but there is an equally important part of the body structure to be aware of – the keel or breast bone, with the strong tripod of bones linking it to the shoulders. Here we find the heaviest bones in a bird's body – the coracoids, and the familiar 'wishbone'. (For simple practical purposes, they can be represented by a halter-like oval, forming the bird's chest.)

Attached to the keel, are the powerful main flight muscles, those that lift and depress the wings. (The lifting muscles, the minor pectorals, work through a pulley-like hole between the shoulder bones to attach to the top of the humerus.)

The rigid vertebrae of the body gives way to a most flexible neck which contains, not the seven bones of all mammals, but a variable number. Most birds have 14 bones in the neck, though a swan for instance has 23. The neck can be stretched or folded into an 'S' shape to bring the head close to the body, enabling the bird to use its bill to fulfil its very varied functions of preening, food gathering, and nest building.

The wing-bones are not unlike those of a human arm, and I shall say more about them in the section on flight. When not in use, the wings are neatly folded to the bird's side, leaving

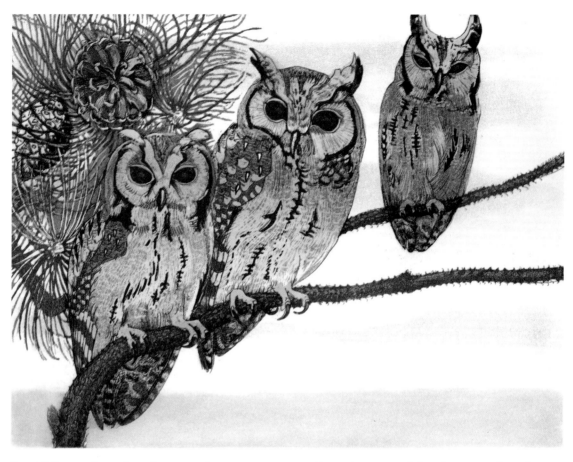

David Koster: Bare-footed scops owls at London Zoo; lithograph and drawing.

The artist has made many large lithographs and paintings of owls. He found these tiny owls in the tropical bird aviary in a far corner of the zoo. "They were enchanting, strung out against an unusually appropriate background of pale coffee-cream and pinkish red, which echoed their own colours. They stared out vacantly from large, black, rather lustreless pink-lidded eyes, and they were so still that they were relatively easy to draw."

Drawing at a zoo has its problems. It is fatal to worry about being watched, and one has to put up with comments and the jostling curiosity of children. Arrive early before the crowds.

Sometimes a model such as an owl can be too still. The artist comments, "This is all right for detailed studies of plumage, but if I wanted to liven them up, I would sometimes dance about in front of the cages waving my arms. Not very ethical, but if I was lucky one of the eagle owls would adopt a threat posture puffing itself up to nearly twice its normal size, and with head lowered and snapping bill would glare at you with its mesmeric, staring orange eyes. This was done so suddenly and with such dramatic effect that you would find yourself backing away." To do these drawings, the artist uses a very soft pencil, like a Black Prince, which can produce marks quickly from very pale to black. He works very fast and from memory.

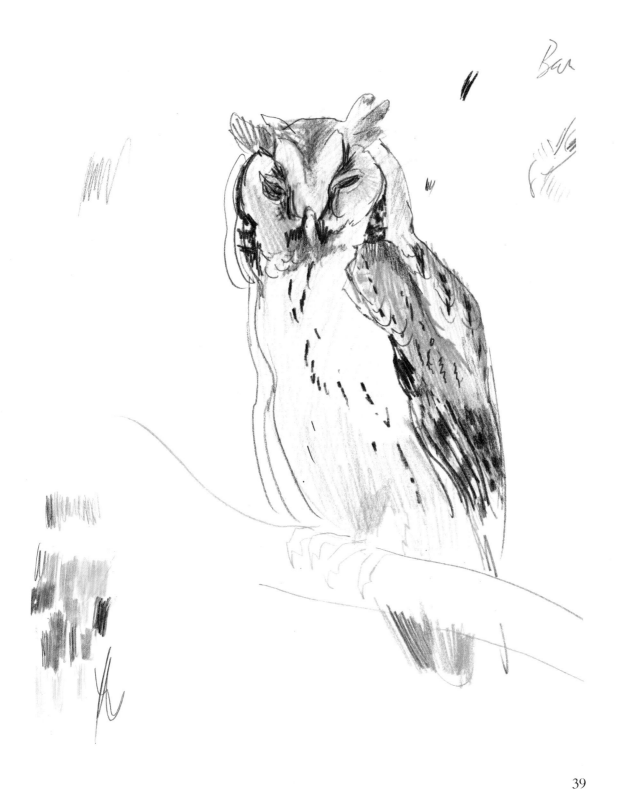

Ban

39

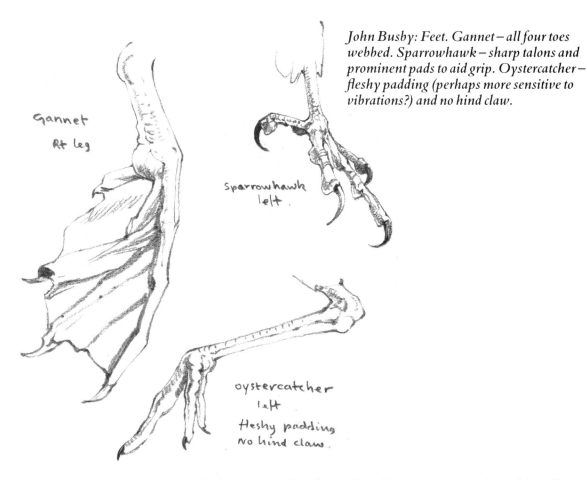

Gannet
Rt leg

Sparrowhawk
left.

oystercatcher
left
fleshy padding
no hind claw.

the long primary (wing-tip) feathers to overlap above the tail. Except in very large birds like herons or eagles, the rest of the wing is partially hidden by overlapping feathers on the shoulders and flanks. In large birds the wrist joint is often visible, as it is when any bird is preparing for flight. A bird stretching its wings (usually a wing and a leg on the same side at the same time) is a beautiful action to watch.

On land the legs are all important, and here the hidden bone structure is vital to an understanding of balance. All back legs begin from a pelvis of some kind. That of a bird is not big and bony and leaves no bump on the surface, but one needs to fix the hidden starting point of the legs quite far back along that axis.

If you imagine a crouching person, there will be a zigzag to the knees then back to the heels and forward to the toes. You will remember from a chicken leg that the muscular thigh has only limited movement and points forward. From knee to heel the bone articulates through almost 180°, and though most of the shin remains behind feathers, and is feathered itself over the muscular part, you can usually see enough of an angle above the heel to guess the whereabouts of the knee. At any rate it will do no harm in your sketches to put in the hidden zigzag whenever you draw legs until you can balance a bird with absolute assurance.

The knobbly ankle joint is difficult to see clearly in the field, and it is useful to make studies from tame or dead birds in order to understand it. In the foot, the tarsal and metatarsal bones are fused as far as the toes, with a strong tendon running down the back. On the shanks of the legs and the feet, feathers usually give way to scales (owls and some gamebirds being among the exceptions). There are large scales down the front, smaller ones on the sides and back. In swimming birds such as grebes and cormorants, the tarsus presents a narrow surface to the water and is broad in side view. Birds' feet, like their bills, are enormously varied in shape and function. They are difficult to draw and one can make bad mistakes by assuming one bird's foot to be like another's. You will come to know each species' peculiarities as you draw them.

Most species have four toes, with the usual arrangement of three in front and one behind. Some running birds have very small hind toes or have lost them altogether. Gannets, cormorants and pelicans have all four toes joined by a single web. Woodpeckers can bring their outer toe to the rear to give two in front and two behind – an obvious advantage on a vertical surface. Kingfishers and bee-eaters have forward toes which are only partially separated. Whatever the toe formula, the number of joints in the toes remains the same. The hind toe has two, the inner has three, the centre toe four and the outer, usually the longest, five. The bones reduce in size as they increase in number. This gives a more flexible outer toe for wrapping round a branch, and a strong, hook-like rear toe to anchor a bird when roosting. The tendon automatically locks the feet when the leg is drawn up to the body. In flight the feet may be drawn up under the body clenched, or stretched out under or beyond the tail. (Remember, even then the knees point forwards.)

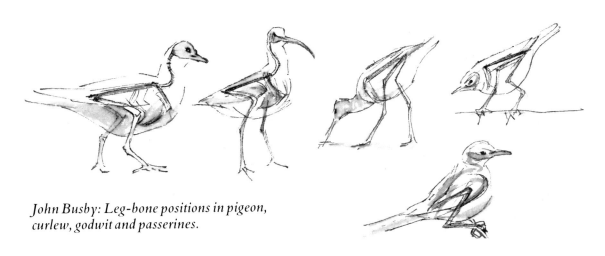

John Busby: Leg-bone positions in pigeon, curlew, godwit and passerines.

41

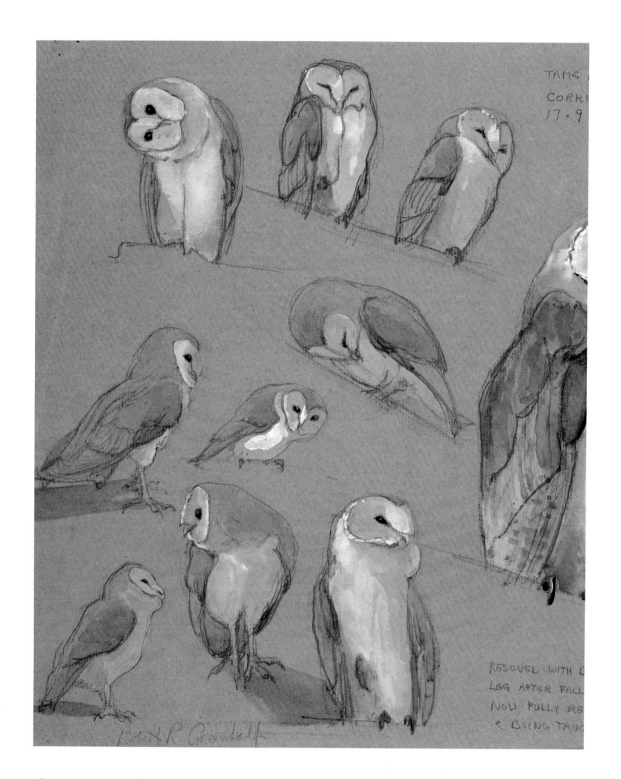

TAMS
CORKU
17.9

RESCUED WITH C
LEG AFTER FALL
NOU FULLY RS
R BSING TAOS

Peter R Greenhalgh

42

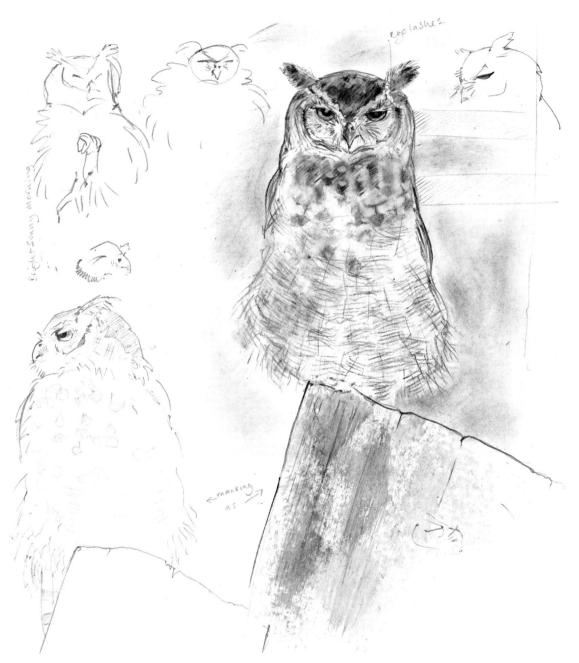

◀ *Robert Greenhalf: Barn owl studies drawn from a tame bird.*

Watercolour with white, on tinted paper. Barn owls are one of the loveliest birds to draw, with their heart-shaped faces, gentle dark eyes, and soft white and ochre and grey plumage.

▲ *Mick Manning: Abyssinian spotted eagle owl; London Zoo.*

Drawn in pencil with crayon and chalk added to give the soft texture of the owl's feathers. The sharp angle of the perch makes a telling contrast to the rounded shapes of the owl.

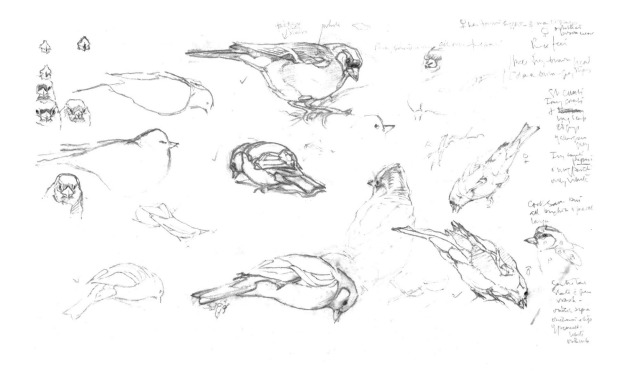

▲ *Eric Ennion: Chaffinches.*
 An exact sideview bird is as rarely seen in
Ennion's drawings as it is in nature. Here a
chaffinch looks down with the obvious intention
of descending for food. This gives a chance to see
the underside of the bird and to note the form of
feathers under the tail. All the lines used
augment the solidity of the bird. Many notes
about colour in the right margin, and front-view
heads on the left.

▶ *Alexander Campbell: Snowy owl.*
 Not many people have seen the only British
snowy owls on remote Fetlar, or as occasional
winter vagrants to the north, but they do breed
successfully in zoos, and the opportunity to
draw them is welcome. This female, drawn in
charcoal has all the softness of an owl as well as
its latent menace. The charcoal marks flicker
round and over the feather masses, following the
strong barring of the plumage and the fall of
light and shade. It is a drawing of tremendous
energy, made even more so because the owl fills
all of the space.

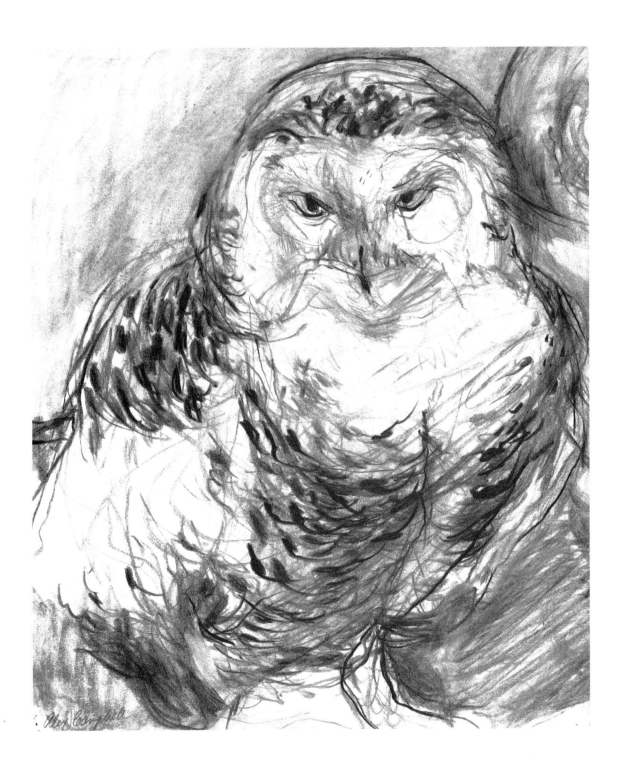

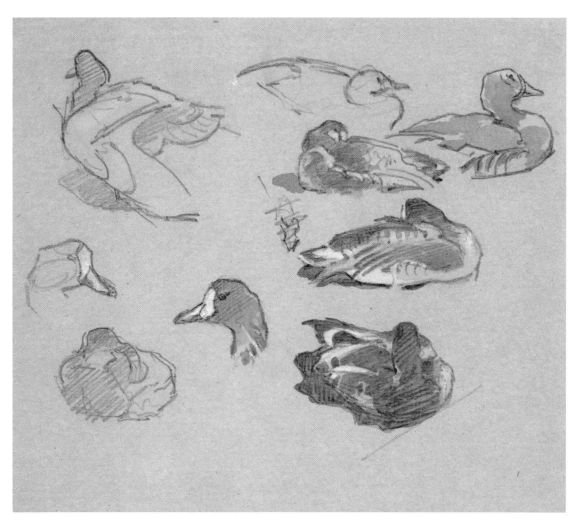

▲ *Eric Ennion: White-fronted geese. Soft pencil and wash; drawn at Weyhill Hawk Conservancy.*

▶ *John Busby: Studies of a dead swallow.*
I never miss a chance to draw from any freshly dead bird found. These are not measured drawings except by eye. I was not trying to draw the bird in lifelike positions, only those which were beautiful in death. No matter how many times you may draw a particular species, always take a fresh opportunity when it comes. One then realises how different individuals of the same species can be, and how many variations of plumage can take place through the twice-yearly moults.

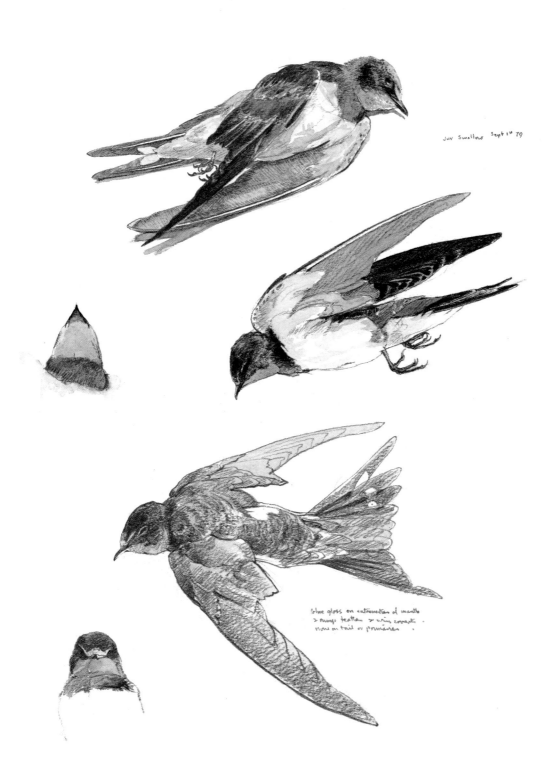

Juv Swallow Sept 1st 79

blue gloss on extremities of mantle
& wings feathers & wing coverts .
none on tail or primaries .

47

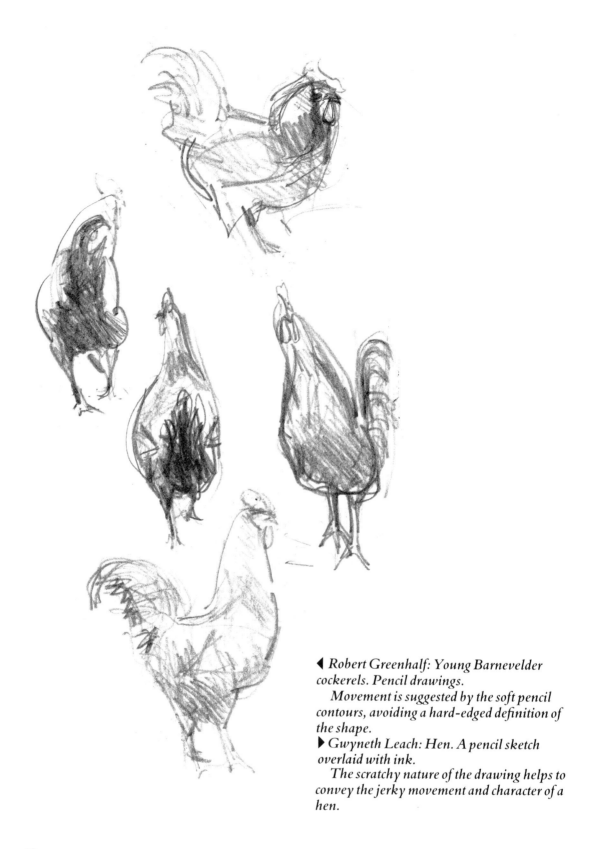

◀ Robert Greenhalf: Young Barnevelder
cockerels. Pencil drawings.
 Movement is suggested by the soft pencil
contours, avoiding a hard-edged definition of
the shape.
▶ Gwyneth Leach: Hen. A pencil sketch
 overlaid with ink.
 The scratchy nature of the drawing helps to
convey the jerky movement and character of a
hen.

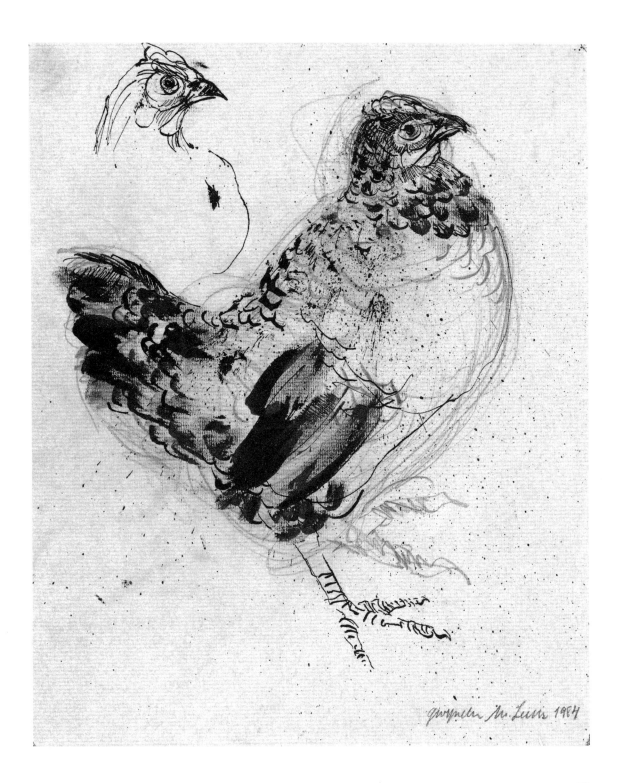

Gwyneth M. Lewis 1984

49

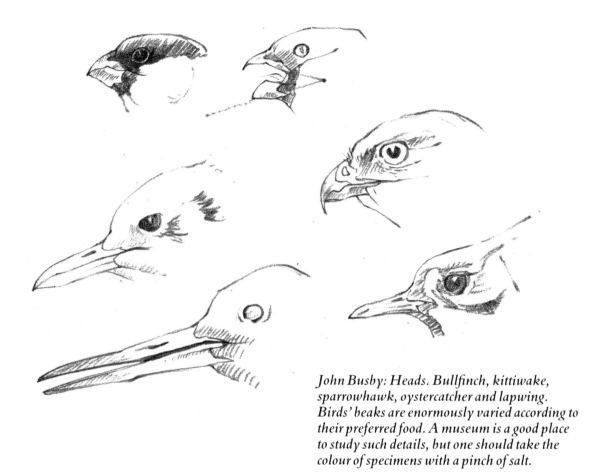

John Busby: Heads. Bullfinch, kittiwake, sparrowhawk, oystercatcher and lapwing. Birds' beaks are enormously varied according to their preferred food. A museum is a good place to study such details, but one should take the colour of specimens with a pinch of salt.

The most active part of a bird is its head, carrying those ever-alert eyes and the beak, its all-purpose precision instrument. The skull is shaped rather like a bath pumice stone, tapering to the beak and broadest at the apex of the eye socket, or just behind the eye. This socket is unusually large for the proportions of the skull, and one can often see the presence of the ridge of bone above the eye. The change of form here from top of head to side is most abrupt round the eye. There is often a noticeable eyebrow, emphasised by light and shade and particularly obvious in a gull.

The shape and position of the eye is a vital clue in setting the angle of the head. As the head turns, the eye becomes more elliptical. Spend some time with tame models just drawing heads and eye placings. Highlights can help to show the convex surface of the eyes, but they need careful observation or they will become mechanical additions: one does not *always* see a highlight in the field. Above all, a bird's eye should express an outward-looking energy.

Beaks come in all shapes and sizes, designed for a bird's feeding habits rather than for the other uses to which they are put. In the field quite subtle differences between the beaks of closely related species – sandpipers for instance – can be critical factors in their identification.

50

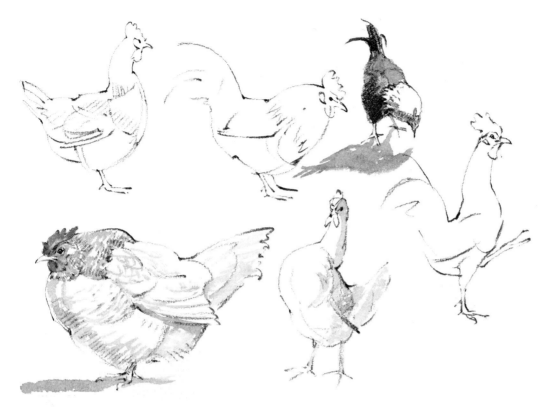

*John Busby: Studies of domestic hens. Feathers
cloak a bird's frame and can give it a wide
variety of shapes.*

When the beak is open, the jaw is hinged well beyond the visible gape of the mouth, towards the base of the skull. Too often one sees an open beak drawn like an Easter chicken, or completely unhinged. Some birds have a degree of flexibility in the upper mandible – this is very noticeable in a parrot, for example, and even a long-billed bird like a snipe can flex the tip of its probing beak. The eye must always be placed above a line between the upper and lower mandibles, but watch out for a change in angle in some birds.

Feathers do not grow evenly from the skin of a bird as hairs do from mammal. They grow in groups from pterylae, or tracts. The tracts are found covering the head (divided into sub-units); running down the spine and over the pelvis to cover the back and rump and running on each side of the body to cover the upper breast and flanks. Another tract produces the scapular feathers covering the base of the wings and shoulders; another, feathers at the base of, and behind the legs. Other tracts give rise to the wing and tail feathers, and those covering the legs. Between the tracts there will be either down feathers or bare skin.

The fact that feathers form groups actually makes drawing easier. However beautiful and complicated a bird's plumage, always make sure of the feather masses before drawing

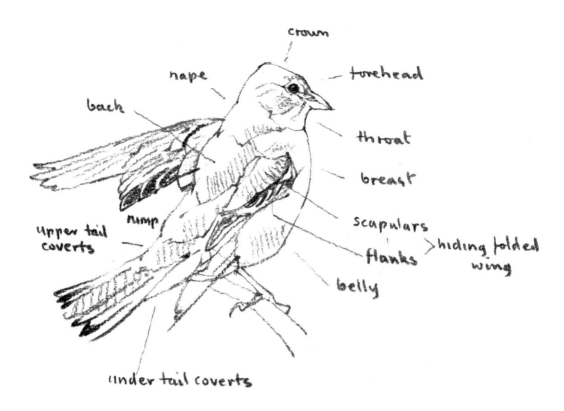

crown

forehead

nape

throat

back

breast

scapulars

hiding folded wing

flanks

upper tail coverts

rump

belly

under tail coverts

John Busby: Feather masses.

individual feathers. The surface edges of these masses are often marked by a change in pattern or colour and are easy to see. Head feathers are usually small and tight, but a bird may carry a crest or a ruff. The forehead may be raised in display, or the throat in song. Neck feathers give the impression of bulk, but this is an illusion. When a bird draws its neck in to the body, the feathers seem to dissolve into each other, but they move with the neck and swivel against the body feathers as the neck turns. This is very noticeable in a domestic fowl or an owl. It is one of the most important lines to look for when drawing birds, as the elliptical section it gives will help to make a bird look solid. (Ellipses look like circles turned in space, and if you can draw circles from any angle, you can draw virtually anything!)

Once the main body feather masses are understood as groups it is easier to see both the behaviour and the solidity of a bird, and the true garment-like purpose of all those thousands of individual feathers. A bird preens in order to make each feather a part of the whole covering, so there is no reason for an artist to do the opposite and paint them one at a time.

52

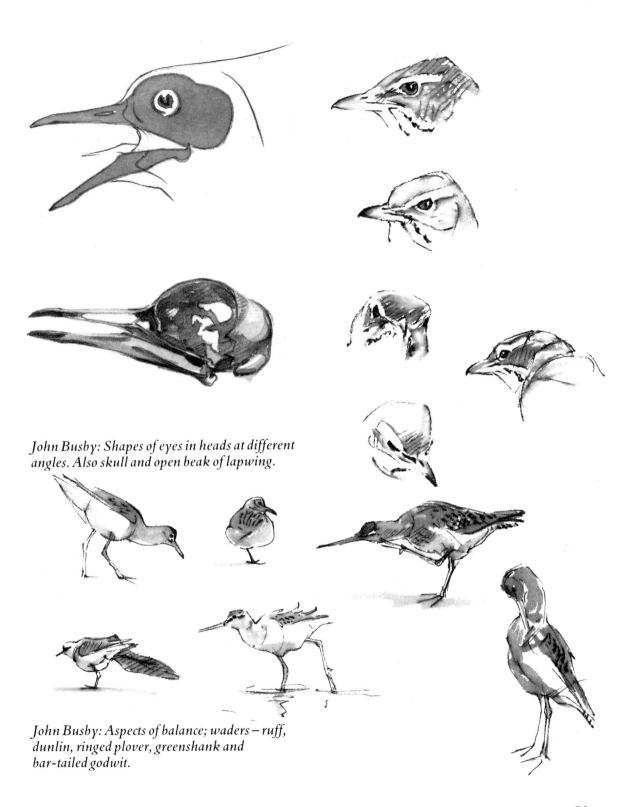

John Busby: Shapes of eyes in heads at different angles. Also skull and open beak of lapwing.

John Busby: Aspects of balance; waders – ruff, dunlin, ringed plover, greenshank and bar-tailed godwit.

Studies of dead birds are an important part of learning the finer details of a bird's body. With life and movement gone, no amount of detail will hinder the unity of the bird. A keen student will always take advantage of the opportunity to draw a dead bird; to increase an understanding of its anatomy and plumage. If nothing else, always draw the beaks and feet of any freshly dead bird you find, as these are the parts most difficult to see clearly in the field.

Look at the drawings of dead birds by Pisanello, Dürer, and of course Tunnicliffe. They are works of art in their own right. I always think a dead bird should look dead and take whatever form is appropriate to its resting place.

In time a knowledge of the essential anatomy of a bird becomes an intuitive part of seeing, and provides the key for drawing a bird in any position convincingly.

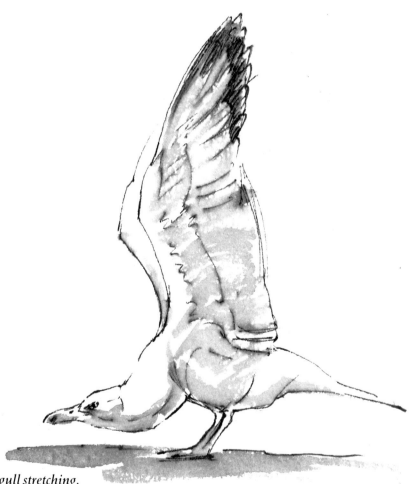

John Busby: Herring gull stretching.

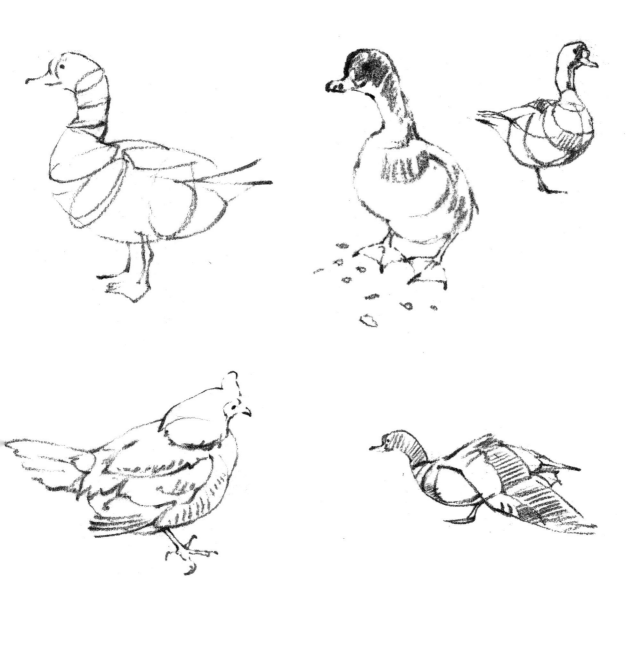

John Busby: Studies of ducks and hen. Using the contour-revealing line of feather masses and plumage pattern to build the solid form of the bird.

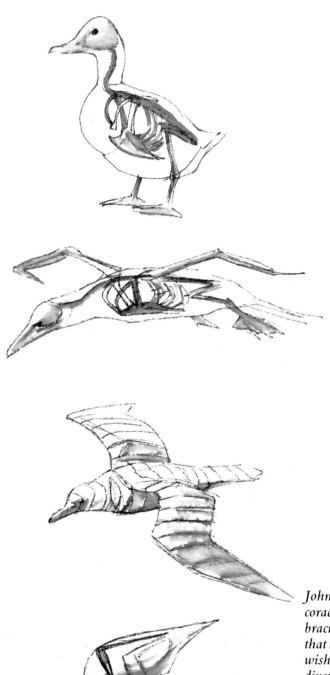

John Busby: Positions of the 'wishbone', coracoids and breastbone, forming the pectoral bracing of bones in a duck and a gannet. (Note that the gannet's sternum is extended to join the wishbone, giving greater strength to this plunge diver.) Heavy birds with rapidly beating wings generally have deeper breastbones – eg gamebirds and auks.

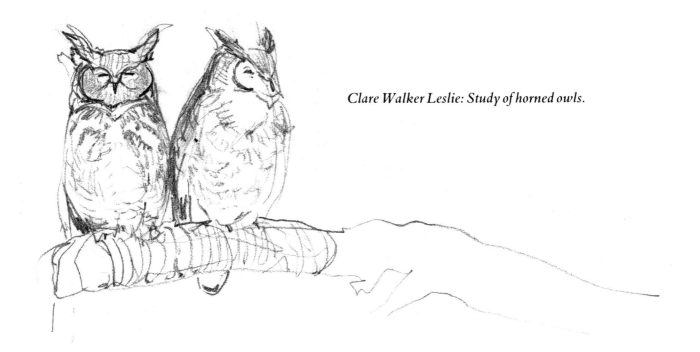

Clare Walker Leslie: Study of horned owls.

Donald Watson: Young blackbird.

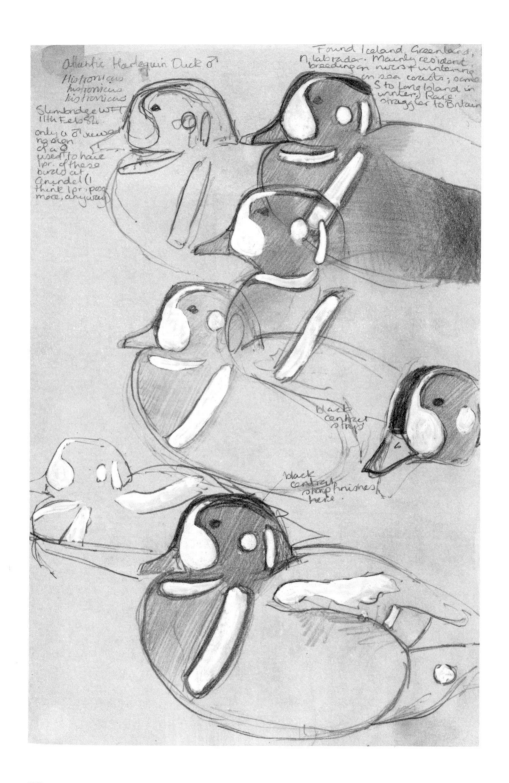

Atlantic Harlequin Duck ♂

Histronicus
histronicus
histronicus

Slimbridge WFT
11th Feb 84

only a ♂ viewed
no sign
of a ♀
used to have
1 pr. of these
birds at
Arundel (1
think 1 pr; poss
more, anyway)

Found Iceland, Greenland,
N. Labrador. Mainly resident
breeding on rivers & wintering
on sea coasts; some
S to Long Island in
winter. Rare
straggler to Britain

black
contrast
strap

black contrast
strap finishes
here.

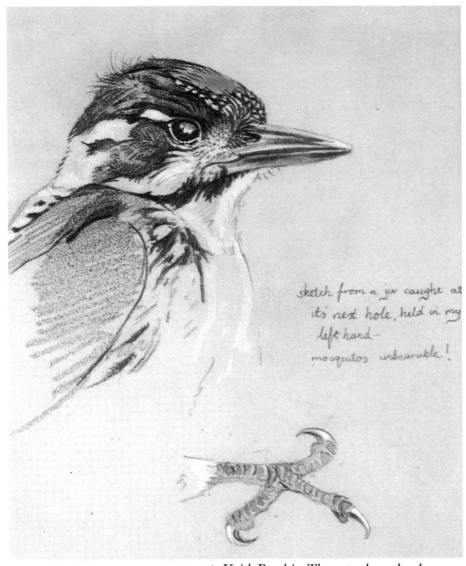

sketch from a juv caught at its nest hole, held in my left hand — mosquitos unbearable!

▲ *Keith Brockie: Three-toed woodpecker; Finland.*

A juvenile caught at its nest-hole for ringing; drawn while being held in the left hand with sketchbook on knees: coloured crayon and pencil. Bird-ringers have an ideal opportunity to study wild birds in the hand before they are released, but time is limited if stress is to be avoided.

◀ *Richard Kemp: Harlequin drakes, drawn at Slimbridge Wildfowl Trust.*

Harlequins have extraordinary abstract markings like a camouflaged warship, and this geometry has been emphasised to fix the pattern more clearly in the artist's memory.

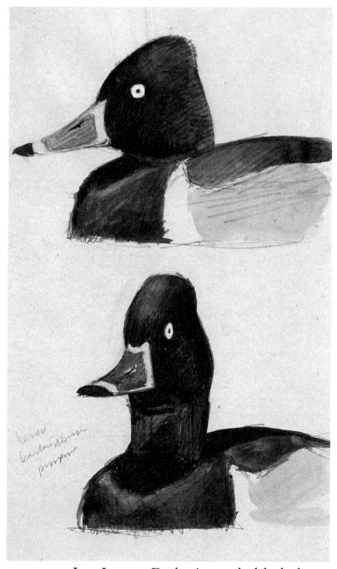

Lars Jonsson: Drake ring-necked duck, drawn by a lake in Missouri.

Only at close range and in good light does the maroon 'ring' round the neck of this handsome duck show clearly. Head shapes of different species of duck are often the most recognisable diagnostic features. This one has all the character of a fine piece of sculpture – strong geometry and clean lines.

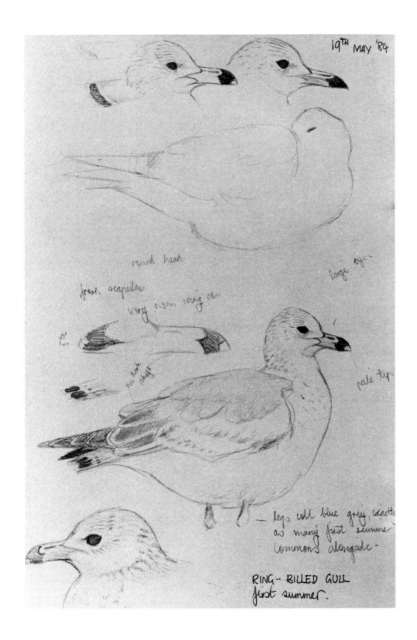

Killian Mullarney: Sketches of a first-summer ring-billed gull, a vagrant from North America.

At first glance, the ring-billed gull could be mistaken for a common gull, hence the artist's interest in the differences in the shape and markings on the bill and in the winter-flecking on the gull's neck. The heads of the two species are compared at the top of the page. It is important always to fix the overall shape and proportions before adding plumage details. Killian Mullarney has not sacrificed 'jizz' for detail.

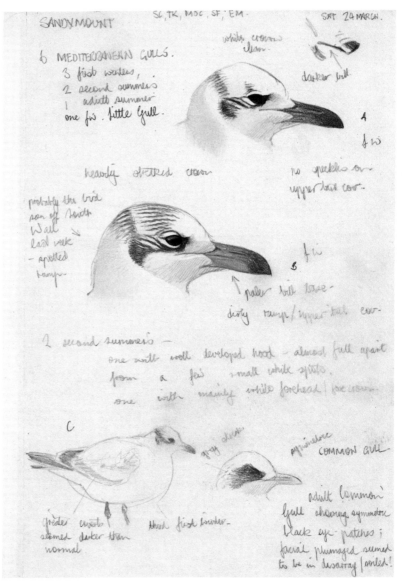

The sketch notes read (handwritten):

SANDYMOUNT SC, TK, MOC, SF, EM. SAT 24 MARCH.

6 MEDITERRANEAN GULLS.
3 first winters,
2 second summers
1 adult summer
one fw. Little Gull.

white crown clean.

darker bill

fw

heavily streaked crown

no speckles on upper tail cov.

probably the bird seen off South Wall last week — spotted rump.

fw

paler bill base.
dirty rump / upper tail cov.

2 second summers —
one with well developed hood — almost full apart
from a few small white spots.
one with mainly white forehead / crown.

C

grey down

approximate COMMON GULL

greater coverts seemed darker than normal

third first winter.

adult common gull showing symmetric black eye patches; facial plumage seemed to be in disarray / soiled!

▲ Killian Mullarney: Heads of Mediterranean gulls, seen at Sandymount, Ireland.

The markings on the heads of these first-winter birds showed individual variations which enabled Killian to keep track of their comings and goings. Two months later, with increased numbers and the uniform black summer heads, it was impossible to tell them apart.

▶ Killian Mullarney: Cormorant heads.

There are careful notes about the age of the birds according to the colours and marks on the bill and lores (the fleshy skin between the eyes and the bill).

"It is nice to sketch large, co-operative birds like cormorants."

The drawing shows a good eye for shape, and gives a satisfying sense of strength and structure

62

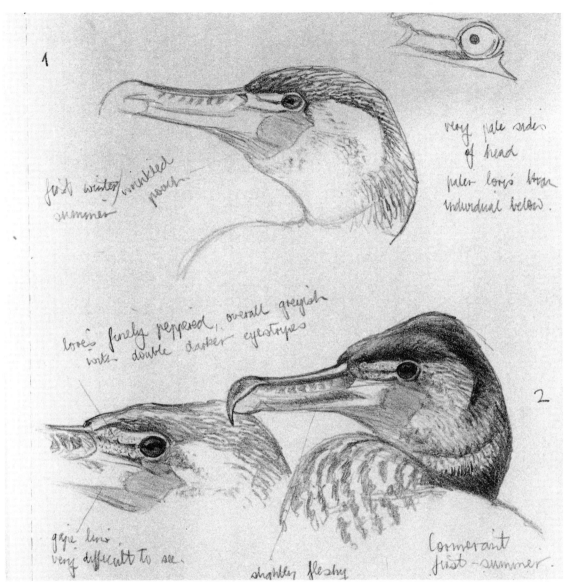

1

very pale sides
of head
paler love's than
individual below.

first winter/wrinkled
summer pouch

love's finely peppered, overall greyish
with double darker eyestripes

2

gape line,
very difficult to see.

shabbey fleshy

Cormorant
first-summer.

to the heads. *The angle of the eye shows its slight downward and forward inclination. Note the second bird's slightly raised crown feathers.*

Of his earlier drawings Killian Mullarney says; "I fell into the trap of allowing my field notebooks to become showpieces, since people would often ask to look through them, rather than the sketchbooks *they should have been."*

He finds that his keen interest in identification and in looking for unusual species can be counter-productive. "It is the root of an inner conflict over how much of my time in the field ought to be devoted to sketching whatever is on view; and how much time I can afford to spend searching through flocks etc, and not *sketching."*

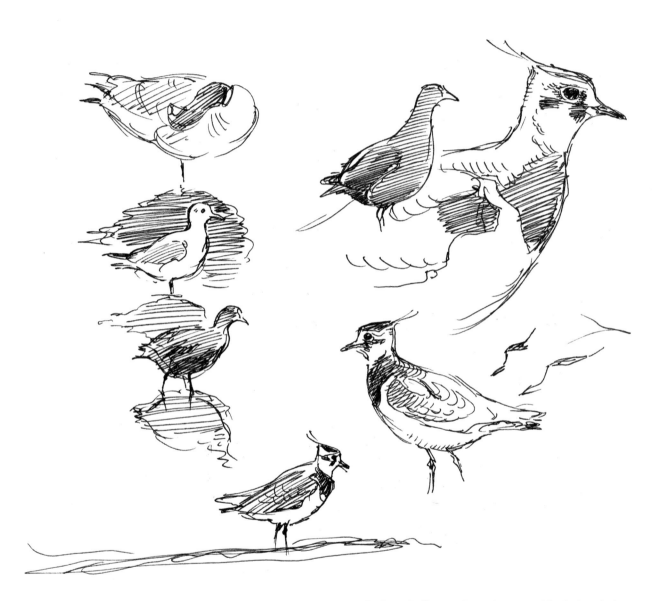

Robert Gillmor: Canada goose, black-headed gull, moorhen and lapwing; pen drawing made from a hide at Gibraltar Point.

"The four species were exactly in line, but by the time I got down to the lapwing it had moved to the right!" Drawn very quickly to fix the moment.

64

4: Birds in the Bush

DRAW from tame or familiar wild birds to begin with. The better you know a bird, the more confidently you will be able to respond to it. Those seen fleetingly through binoculars are best ignored until you have more experience, and can retain a lot of what you see in your memory. Birds at a winter feeding-table, which can be watched from a window; ducks coming for food on a park lake, or gulls to a fishing harbour – any occasion where a situation is repeated, will give more chance for your drawing fragments to turn into completed birds. Wild birds attracted to a local farm or a zoo by easy pickings are less timid than usual, and one can watch finches, starlings, crows, wagtails, gulls, moorhens and pigeons, without taking extreme measures to hide. A car is often ignored by birds, and it makes a comfortable, if not very manoeuvrable viewing hide, with the advantage of support from partly wound-down windows for binoculars or telescopes. (You can buy telescope brackets which attach to a car door frame.)

Hides provided by organisations like the RSPB on nature reserves are a godsend to the artist, but to me, there is nothing better than sharing the birds' environment (and weather conditions). Without the enclosed feeling of a hide one can be alert to sounds and to movement seen out of the corner of an eye, and open to the unexpected. A bird artist has all the excitement and frustrations of a hunter, and the need for similar subtlety of field-craft. It is a hopeless task to pursue birds with pencil at the ready! However careful you are as a stalker, you can be certain that the birds have seen you coming and know just how close they will let you come. It is far better to sit and wait for birds to come to you or approach them casually, avoiding stealth. Birds wake early in their search for food, and you will usually see more activity between dawn and breakfast than at any other time of day.

As field knowledge accumulates, the odds against seeing wild birds close enough to draw can be shortened. Many patterns of behaviour are predictable. The major influences on courtship, breeding, flocking and migration are the changing seasons. On the sea-shore or estuary, the tide is a considerable factor in knowing what is likely to be seen and where to position yourself. For example, waders may be scattered far and wide at low tide, but will be driven close in-shore to favoured resting places at high tide. One can arrive ahead of time and wait; keeping below the bird's skyline, if possible in the shelter of rocks or dunes with the sun behind you. An incoming tide will also encourage seaducks, grebes and divers to follow sand-eels closer to the shore. Another winter activity is roosting; thrushes, finches, starlings and many other species will gather at dusk, forming large flocks to spend the night together. Geese and rooks follow regular flight lines between roosts and feeding areas. In summer a woodland clearing, especially near water, would be a good sitting place. (We are not the only creatures to enjoy sunshine and shelter from the wind!) A tree at one's back may be enough cover; stillness matters more than camouflage, though one should avoid conspicuous colours at all times. Woodland birds are often curious, and will sometimes peer at one closely through the leaves. They can be attracted by imitating alarm 'clicks', or what the Americans call 'Pishing'.

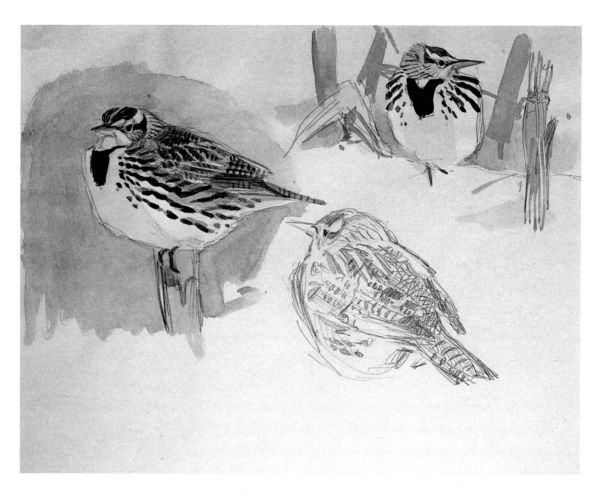

▲ Lars Jonsson: Eastern meadow lark.
 Studies of an inactive but still very alert bird,
its bright yellow breast set against background
washes of cool blue-greys. There is a lightness
in the handling of detail in all Lars Jonsson's
work which keeps the spirit of the bird intact.
The observation is precise but never pedantic,
fussy or inexpressive.

▶ Lars Jonsson: Gyr falcon.
 This watercolour sketch was made in Alaska,
from a distance, using a powerful telescope so
that the bird was not disturbed. It expresses very
subtly, with delicate washes of pale yellows
against violet and blue greys, the direct and
reflected sunlight on the bird. Powerful curves
and angles in the rocks induce a stillness in the
resting bird. A sense of 'presence', Lars Jonsson
says, is the most important feeling he tries to
achieve in his paintings, and he believes in as
intuitive a 'direct line' as possible between eye
and paper (backed by much observation and
practice). "Do it the way it comes to you!"

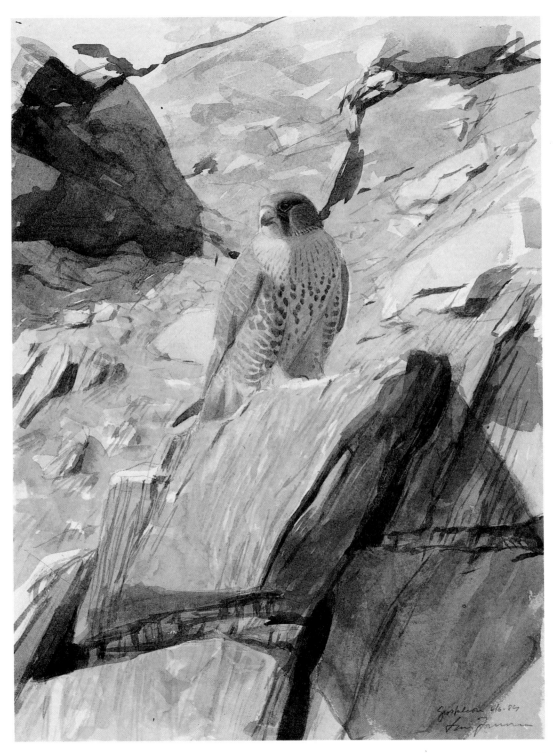

Gyrfalcon 6/6 -84

67

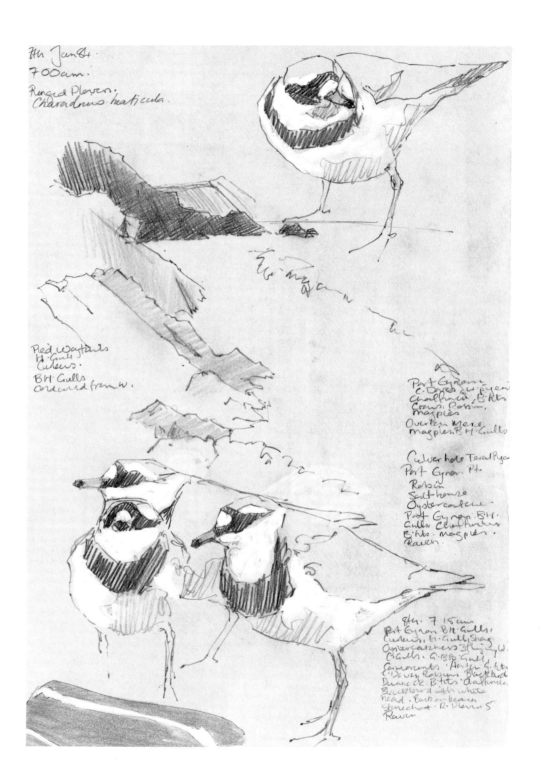

7th Jan 84.
7.00am.
Ringed Plover.
Charadrius hiaticula.

Pied Wagtails
H. Gulls
Curlews.
B.H. Gulls
ordered from W.

Port Gynon.
C. Doves Wrens
Chaffinch, B.tits
Crows. Robin,
Magpies
Overton Mere
Magpies. B.H. Gulls

Culver hole Terol Plyon
Port Gynon Pt.
Robin
Salt house
Oystercatcher
Port Gynon B.H.
Gulls Chaffinches
B.tits. Magpies.
Raven.

8th. 7.15am
Port Gynon B.H. Gulls.
Curlews. H. Gulls. Shag.
Oystercatchers 3 flying W.
C. Gulls. G.B.B. Gulls.
Cormorants. Aerofer S.tits
C. Doves Robins. Blackbird
Dunnocks. B.tits. Chaffinches
Blackbird with white
head. Rock on beach
Stonechat. R. Plovers 5
Raven

◀Richard Kemp: Ringed plovers.

In groups, strongly patterned birds lose their individual plumage shapes in new, abstract configurations (as in this group of three), intriguing to an artist and confusing to a predator. Richard Kemp makes a habit of always noting the scientific name of the birds he draws. This is a good way to learn these names, and helps anyone not familiar with English nomenclature.

▶John Busby: Double crested cormorants off the New England coast.

The golden rule at all times is to keep a low profile and to let the birds get used to you as a harmless presence. One must always respect the privacy of nesting birds. It is only at a crowded sea cliff colony that one can watch and draw from a fairly close distance without causing disturbance. (Disturbance at or near the nest of species listed on the First Schedule of the Wildlife and Countryside Act, 1981 is a criminal offence.)

Binoculars are necessary for watching birds at any distance at all. Ideally they should be easily adjustable for focusing and not too powerful, x7 or x8, and light in weight. Miniature binoculars are very good in woodland where there is much looking up into trees and they weigh next-to-nothing round your neck. Larger models may need the support of a tripod or simply a stick.

The drawback of binoculars is that you need both hands to hold them, so for any sustained watching of a fairly static bird, it is a great advantage to have them independently supported. A tripod-held telescope gives even greater magnification though the field of view is considerably less. I find it more difficult to look with one eye and then adjust to two when drawing, but one advantage of greater power is that one can stay further back from the birds and often watch behaviour unaffected by human presence.

Birdwatching artists may have differing reasons for drawing in the field. The keen ornithologist will no doubt want to draw primarily to establish the details relevant to each species, building up knowledge of identification from field experience. There is much to be learned from direct observation which cannot be understood from photographs or museum specimens – above all about the 'jizz', or attitude and movement of a bird related to its behaviour. Differences in jizz can be very subtle but quite distinctive, particularly among waders and ducks, and a thorough knowledge of common birds is the best way to be ready for a rarity when one comes along.

Lars Jonsson: Three studies of cormorants.
The birds' textbook dark plumage is
transformed by light – full of acute and
open-minded observation, with many
unexpected results in colour. Note how
beautifully the edges of the birds are modelled
against the colour and light of the sea, and how
the 'white' belly of the young bird is pitched.
This is field study of a very high artistic calibre.

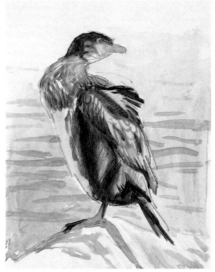

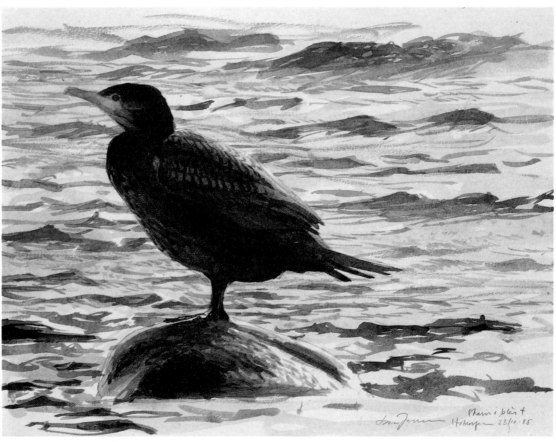

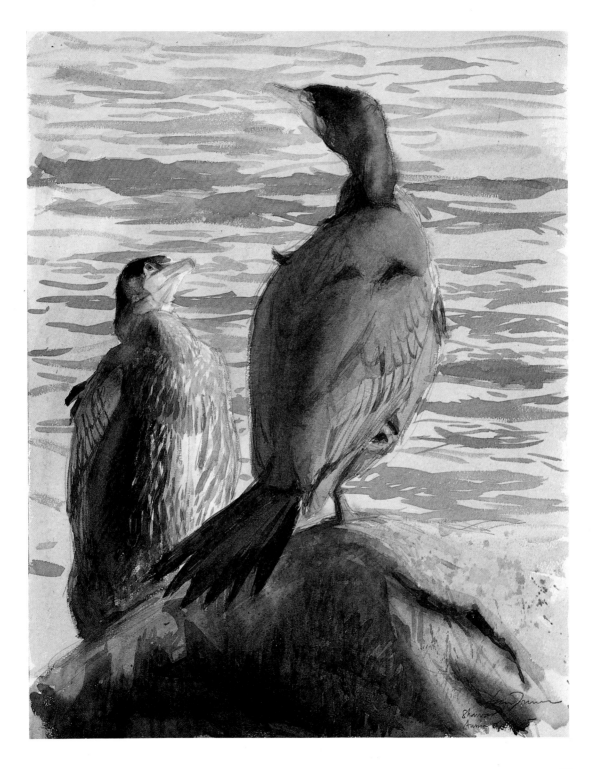

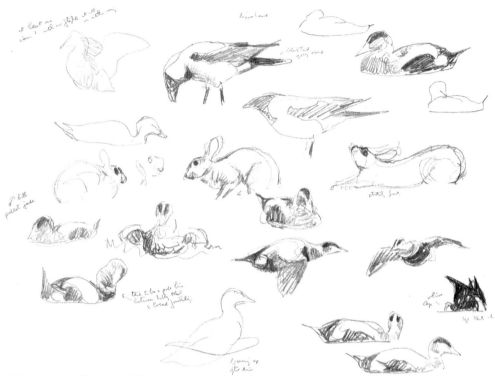

John Paige: Sketches of hooded crows and eider.

Plumage differences you see in the wild are seldom so simplistic as those usually shown in picture books – a cock in full breeding regalia, and a hen bird. They vary with seasonal moults and overlapping stages between, and through the stages of growth to maturity. Look at the drawings of Lars Jonsson, Keith Brockie and Killian Mullarney, and you can see their ability to select important diagnostic features both of jizz and plumage of the individual bird in front of them. Other artist/naturalists might be moved by a rarely-seen moment rather than a rare species – a common bird doing something never seen before is just as exciting to me as a rarity. Well, if I am honest; it is better than a rarity too far away to draw! As Killian Mullarney finds – there is often a tug between the urge to hunt out a rare bird, and the greater drawing potential of taking on whatever comes to you. A rare bird seems to take all one's attention, often to the exclusion of everything else. I find it easier to be alert to the pictorial possibilities of a scene, when watching familiar birds.

A common factor which I hope shows in the drawings of all the artists represented here could be the enjoyment of the experience of birdwatching. I certainly hope mine convey a sense of the smile that is never far away as I watch.

In the book *Second Nature*★, David Measures says, "The lure for the painter is the chance of an encounter with a wild creature that allows time enough to make a drawing. Contained in the scribble, in that response of marks and dashes, is something perhaps of the creature's vitality and elusiveness. I find the need to depict – peculiar to man – fascinating, for what a strange desire it is to re-create the intangible quality of things seen."

★ *Second Nature:* Edited by Richard Mabey. (Jonathon Cape)

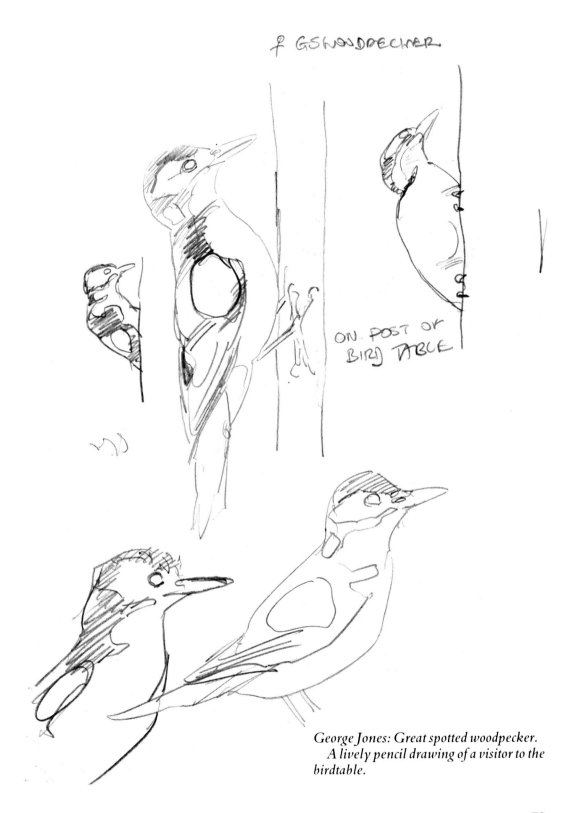

♀ GS WOODPECKER

ON POST OR
BIRD TABLE

George Jones: Great spotted woodpecker.
 A lively pencil drawing of a visitor to the
birdtable.

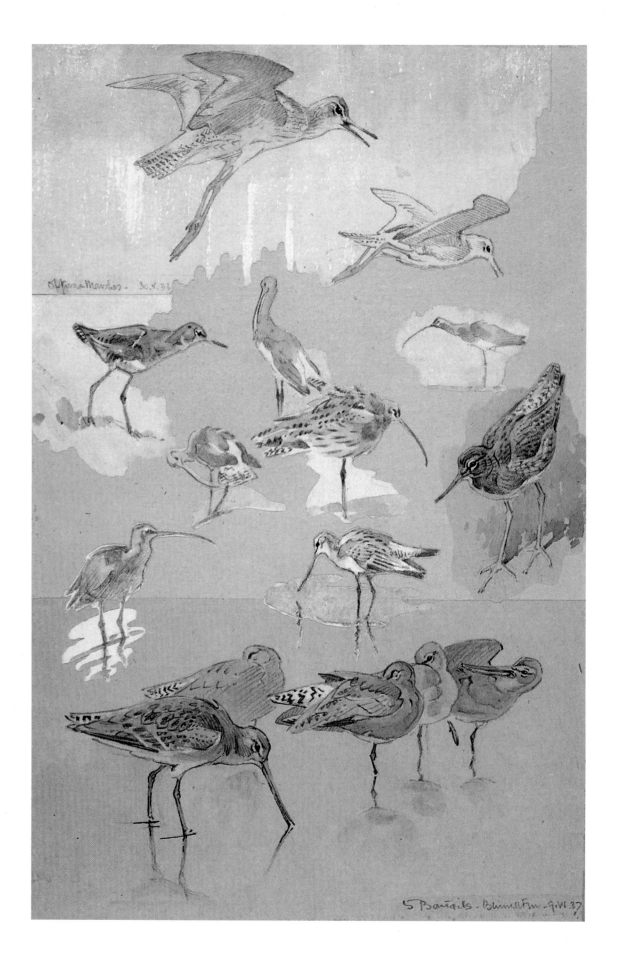

Uferaa Marchen. 30.X.34

5 Bartails. Bumblem 9.VI.37

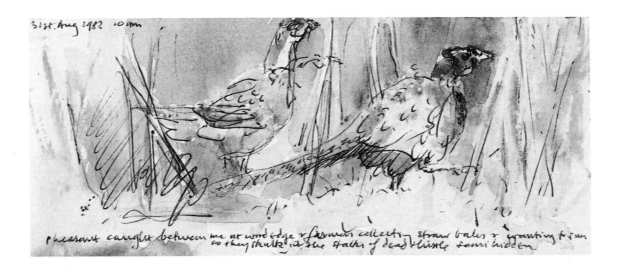

31st Aug 1982 10 am

pheasant caught between me at woods edge & farmers collecting straw bales & wandering to sun so they skulk in the stalks of dead thistle semi hidden

◀ *Eric Ennion: A plate of waders for an unpublished book to be called* Birdman's River.

All Ennion's work was based on a lifetime of field study. These miniature studies are full of freshly observed behaviour and of qualities of light. They are painted using only a few colours with Chinese white on brown paper, cut out and re-assembled. Grouping birds of different scales together can present problems of space, but here there is no awkwardness in the composition.

A redshank hovers jerkily over an intruder, as redshanks will when young are about. The other birds are curlew, marsh sandpiper, a black-tailed godwit and a party of bar-tailed godwits in late-summer plumage.

▲ *David G Measures: Pheasants skulking among dead thistle stalks: The artist's materials are ball-point pen and a miniature box of watercolours; "spittle and my fingers provide the water and brush".*

The Ennion studies are compiled from field notes and painted carefully from memory. The Measures drawing is done on the spot very quickly, retaining both the liveliness and the risks of direct work.

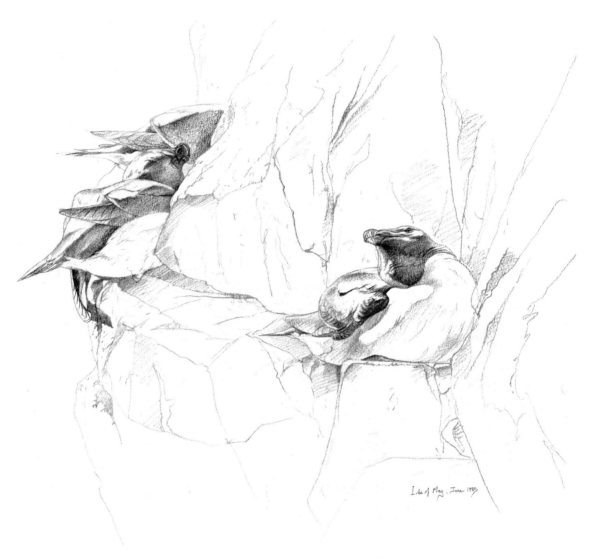

Isle of May, June 1985

▲ *Keith Brockie: Razorbills on the Isle of May; pencil.*

"Cliff-nesting auks offer a multitude of poses in one vista. Being familiar with the species, I look for more unusual poses. This trio was especially appealing in the play of light and shadow, and their obvious contentment as they soaked up the sun; one individual's wing hanging down over the ledge."

▶ *Richard Kemp: Green woodpeckers.*

Sunlight and shadows among tree branches can make unexpected patterns round a bird. The shadow is first sketched as a demarcation line between light and dark areas — the quickest way to note it down without changing gear in mid-drawing. The sketchbook pages are toned down with washes of brown/grey in advance so that both pencil and white crayon can be used effectively.

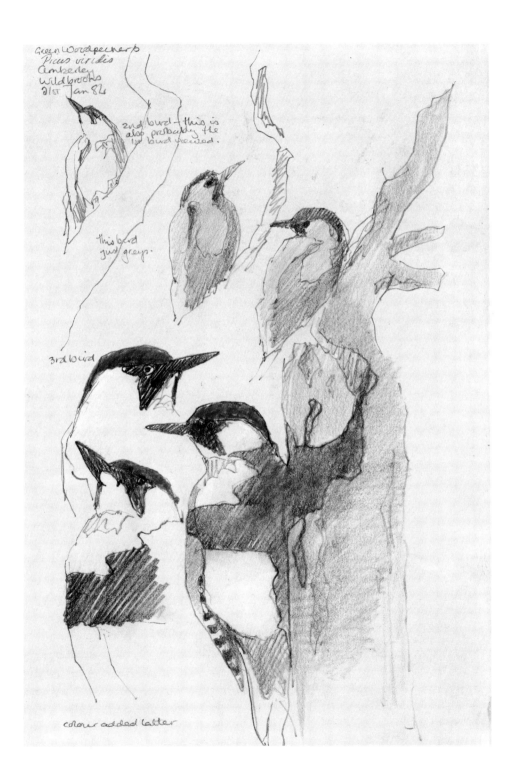

Green Woodpeckers
Picus viridis
Amberley
Wildbrooks
21st Jan 84

2nd bird – this is
also probably the
1st bird viewed.

this bird
just grey.

3rd bird

colour added later

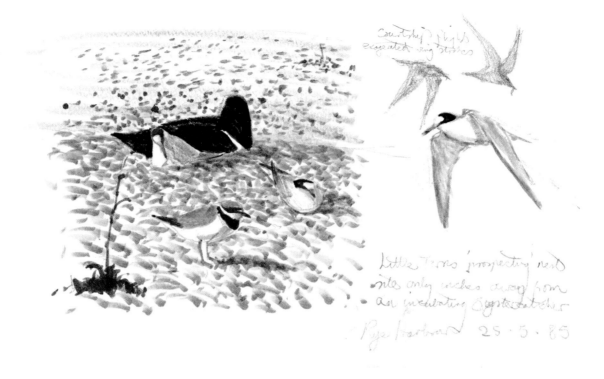

Courtship flights
exaggerated wing strokes

Little Terns 'prospecting' nest
sites only inches away from
an incubating oystercatcher
Rye Harbour 25·5·85

▲ *Robert Greenhalf: Little terns.*
 These birds were making nest-scrapes only inches away from an incubating oystercatcher which made no objection to this intimacy, an event of interest both to a birdwatcher and an artist.
 For this sketch Mars graphic 3000 brush pens were used – useful additions to the sketch bag. The shingle is rendered by dabs of grey and brown.

▶ *John Busby: Shags in different light and against different coloured water. The shadow of the stick-carrying bird fell along its back. Local colours change greatly according to circumstances.*

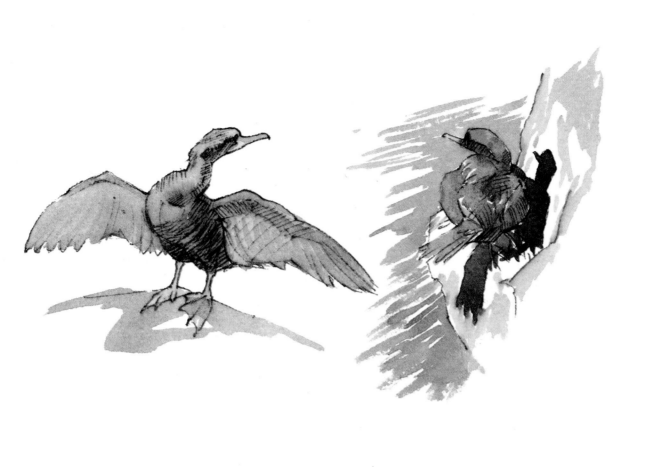

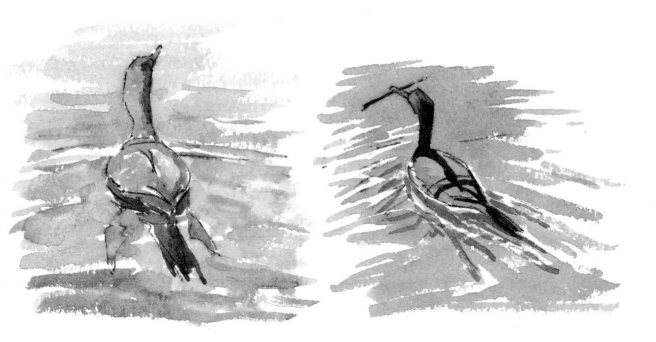

Garden birds

Within 4ft of
the birds?

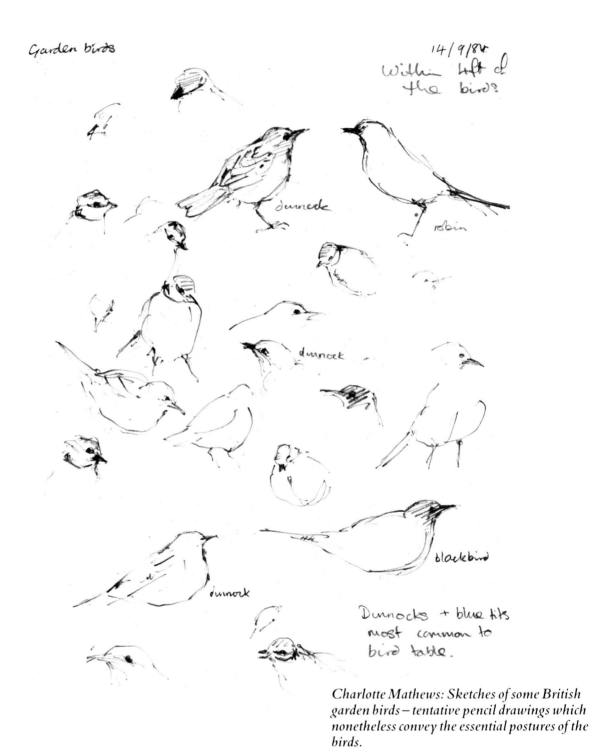

dunnock

robin

dunnock

blackbird

dunnock

Dunnocks + blue tits
most common to
bird table.

Charlotte Mathews: Sketches of some British garden birds – tentative pencil drawings which nonetheless convey the essential postures of the birds.

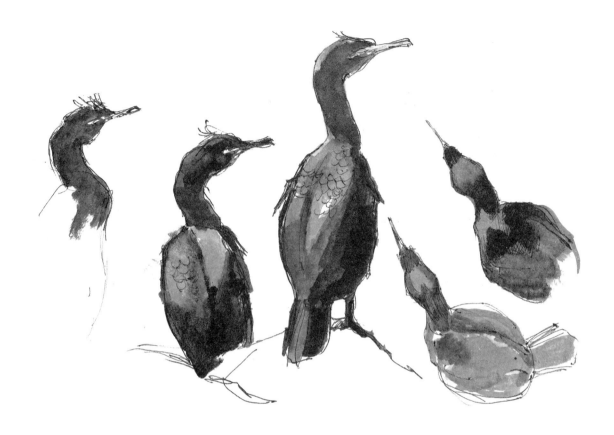

Jack B Flemming: Shags drawn on the Isle of May using biro and a wash of black watercolour, both handled quickly and with the painterly freedom that characterised this artist's fine watercolours.

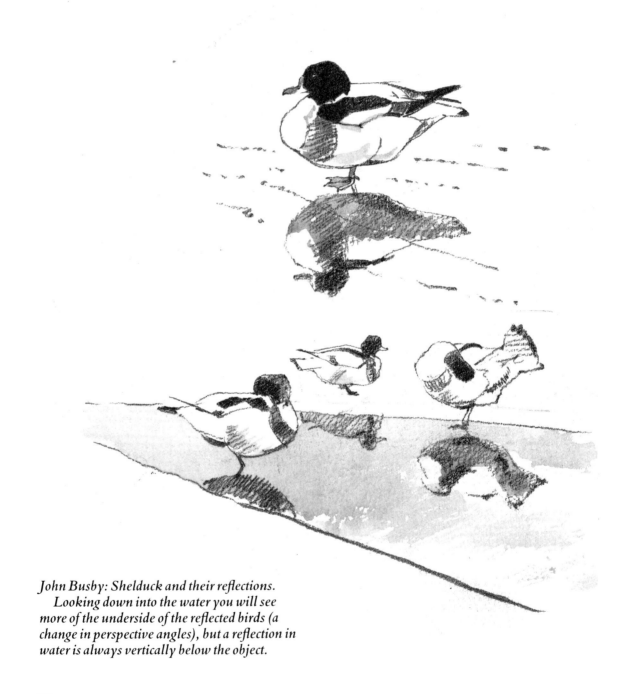

John Busby: Shelduck and their reflections.
Looking down into the water you will see more of the underside of the reflected birds (a change in perspective angles), but a reflection in water is always vertically below the object.

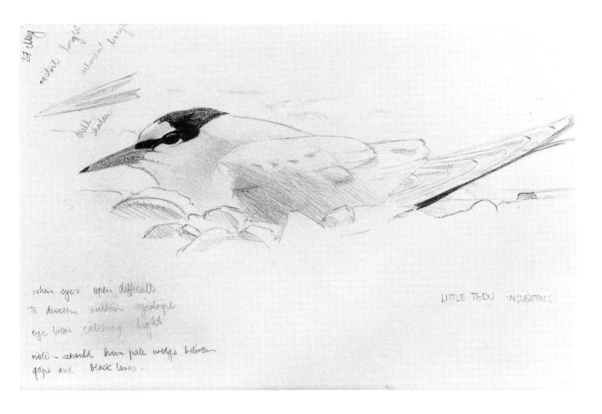

The handwritten notes on the drawing read:

24 May

nestial bright / abroad bright

bill shadow

when eyes open difficult
to discern within eyestripe
eye brow catching light

note - should have pale wedge between
gape and black lores.

LITTLE TERN INCUBATING.

▲ Killian Mullarney: Incubating little tern
seen against the light (detail).

The artist notes "when eyes open, (they are)
difficult to discern within eyestripe: eyebrow
catching light. According to books, it should
have pale wedge between gape and black lores."
Birds do not always conform to their definitive
descriptions, thank goodness!

Overleaf – John Busby: Young moorhens.
Sticking with one bird, however common,
can be very rewarding. Drawing improves with
familiarity, and you learn to appreciate the
everyday life of the species.
The moorhen family on our pond had two
broods, and the 'teenagers' assisted the adults in
feeding the new chicks. These birds were drawn
from a discreet distance using a telescope. (How
marvellously one sees the butterbur and the
water plants with the aid of such magnification
– a real bird's-eye view of their 'jungle'.)
Wing-stretching in any bird is beautiful to
watch – a balletic pose – leg and wing on one
side, then on the other. Moorhens often stretch
both wings and a leg at the same time, the broad
spread of their toes helping them balance.

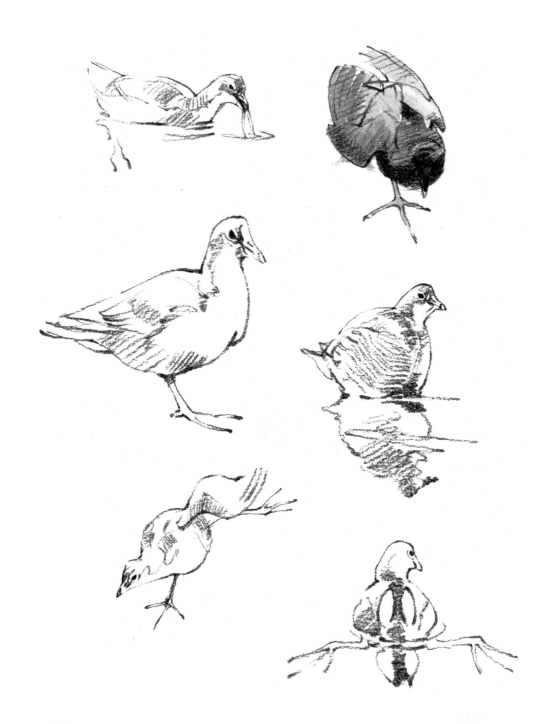

84

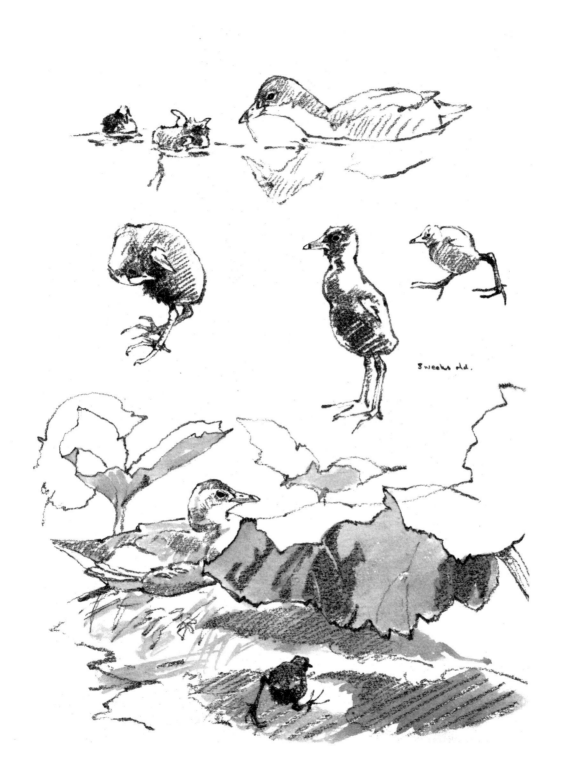

3 weeks old.

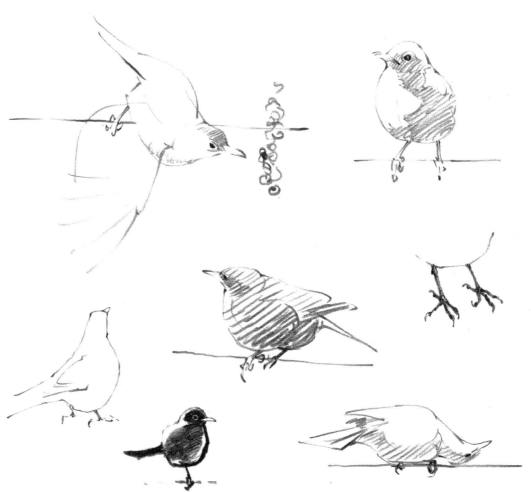

John Busby: Garden birds.

If you look out on a garden, then your room offers the ideal hide from which to draw birds. Whatever the weather outside, you can work in comfort, and spread out paper and paints. Birds soon accept that a transparent pane of glass is shield enough. They completely ignore my dog sitting with nose pressed against the window, and only a sudden movement on my part scares them.

There is a balcony outside my window with a wire-threaded rail, to which a nut basket is fastened. The birds have a choice of levels, and sometimes resemble notes on a musical stave. Finches, blackbirds and tits attack the nuts while robins, dunnocks and an occasional wagtail wait below for fragments.

The colder the weather, the more fluffed out a bird's shape will be.

In drawing it is not necessary to shade-in all the blackness of a cock blackbird. In any case it is far from 'black' as an artist sees the colour; often it is brown, sometimes blue-grey, and can even shine, as a crow's wing does when the light strikes it. It is enough to suggest the bird's blackness, more important to use shading to give volume. One blackbird shot out a wing to restore balance, so quickly that one could see right through it.

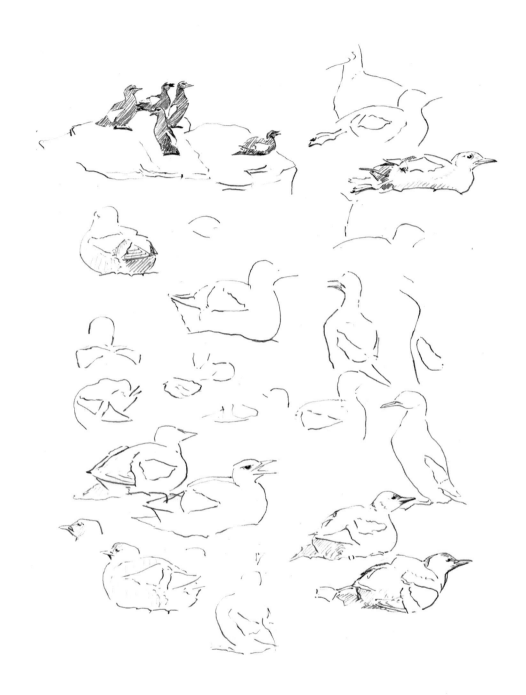

David Boys: Black guillemots.
 Bird shapes and fragments. Jizz and pattern
are all important, the bird's black plumage can
be taken as read.

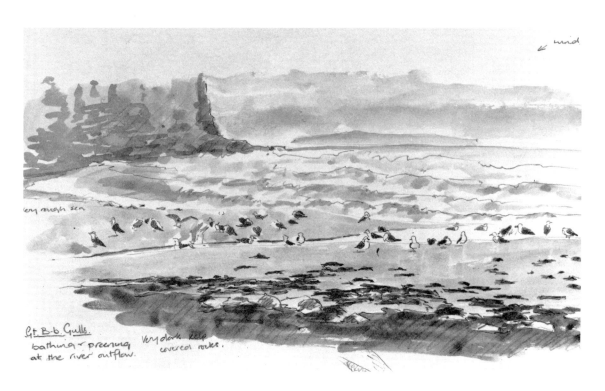

David Boys: Great black-backed gulls on the shore of Rackwick Bay in the Orkneys.

One does not necessarily have to be close to birds to find material for drawing. The distant gulls provide an attractive focus of pattern against the sea and massive cliffs.

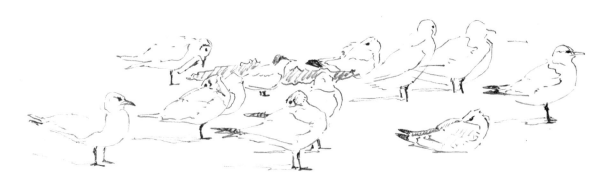

David Boys: Gulls and terns.

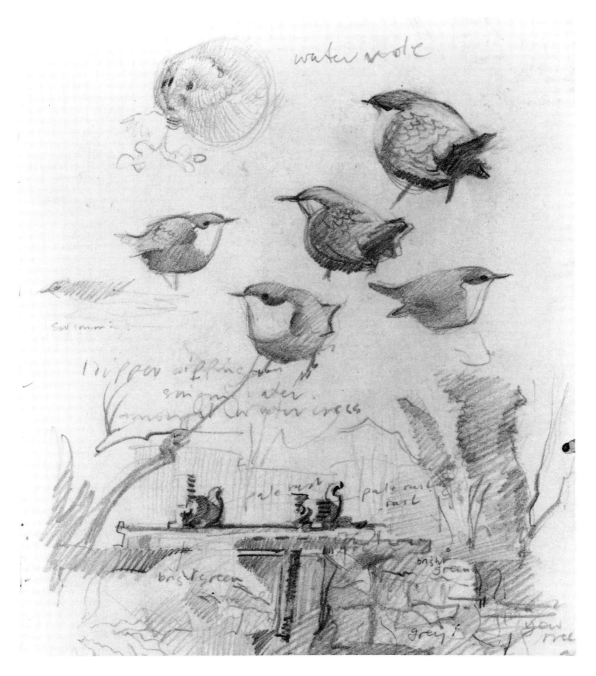

*Peter Partington: Dippers, and a sketch of the
nest-site near an old weir in the Coln Valley in
Gloucester.*

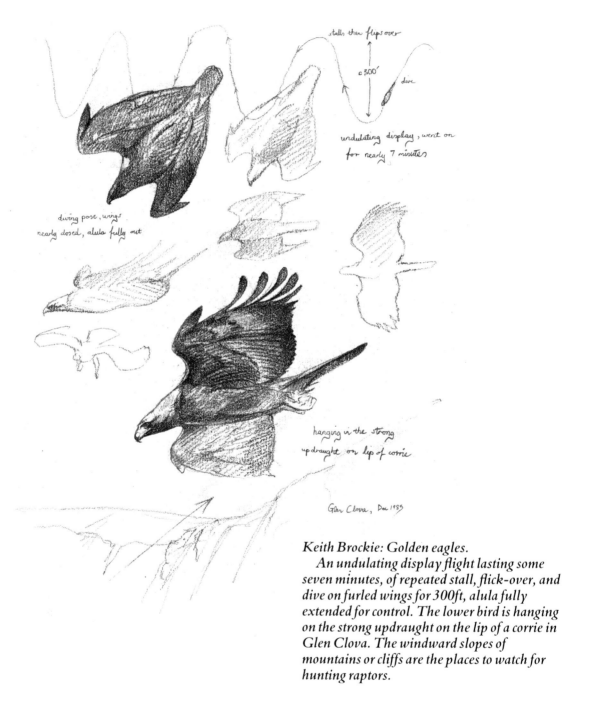

stalls then flips over

c 300'

dive

undulating display, went on
for nearly 7 minutes

diving pose, wings
nearly closed, alula fully out

hanging in the strong
updraught on lip of corrie

Glen Clova, Dec 1985

Keith Brockie: Golden eagles.

 An undulating display flight lasting some
seven minutes, of repeated stall, flick-over, and
dive on furled wings for 300ft, alula fully
extended for control. The lower bird is hanging
on the strong updraught on the lip of a corrie in
Glen Clova. The windward slopes of
mountains or cliffs are the places to watch for
hunting raptors.

5: Birds in the Air

A BIRD in flight, freed from the hold of earth to move into the dimension of space, invisibly supported on currents of air where it may lift above your head or sweep away below you in a twinkling, presents a wonderful challenge to the artist. Can a drawing made in response, fly over the 'air' of a blank page with equal balance and freedom? To draw flight I think one has to begin, in imagination, to sense the air as a bird's wing can feel it. When I was a boy I had a passion for making and flying model aeroplanes and kites. Perhaps this helped to instill a feeling of air in my bones. Today, if I were 20 years younger, I would be a hang-gliding bird-man without a doubt.

Now that modern generations can somewhat clumsily join birds in the air, it may be that flight is a little easier to comprehend than it was to artists of an earlier age. Looking back at bird art generally, even that of the first decade or two of this century, there are few examples of well-drawn flying birds. Most artists kept their birds grounded. Aeroplanes have made us more flight conscious, but today we have another aid to understanding not possessed by our predecessors – photography. Developments in high speed cameras and long-focus lenses have given us pictures of birds in hitherto unseen positions of flight. From early pioneers like Muybridge, who photographed sequences of flying eagles, owls and pigeons, to Charles Voucher, Eric Hosking, and modern wizards like Stephen Dalton, bird photography has turned a blurr of wings into a new poetry of action. Film sequences of flight, especially those following a bird in slow motion, are perhaps the biggest eye-openers of all. Such moments in *The Flight of the Condor* or *The Osprey*, and other films are memorable.

A photograph's frozen moment of action may give us so much to see that if we are tempted to copy a similar degree of detail in a picture, the result can look very static indeed. Unless there is movement in the drawing it may well be better to revert back to a blurr of wings again. However, photographers have helped to explain wing action and to show that a bird does not merely flap its wings straight up and down, but that the forward driving force springs from a figure-of-eight movement of the 'hand' joint. The bones of a bird's wing resemble those of our own arm. If, with arms slightly flexed, you try a flapping motion leading the down stroke with your hand (palms inclined backwards) letting your elbows begin the upstroke before your hand reaches the bottom of the stroke, then turn the palms forward as the hand rises, to end in a backward flick of the wrists, you have a crude imitation of the wing action of a slow, ponderous bird.

A bird cannot fly without movement of air over the wing surfaces. Either it will run or spring up to gain that initial speed, or a wind current will give sufficient lift, but also the changing angles of its wing-strokes will have the same effect. The transverse shape of the wing, with its strongly cambered top surface, causes the reduction in pressure which lifts the bird into the air.

It is easiest to see the mechanics of flight in action in the larger, longer-winged birds capable of gliding and leisurely movement through the air. Gulls are the commonest and usually the most convenient examples to observe, and in their wings the arm-like structure can be seen most clearly. The bones, and therefore all the adjusting mechanisms, are at the front of the

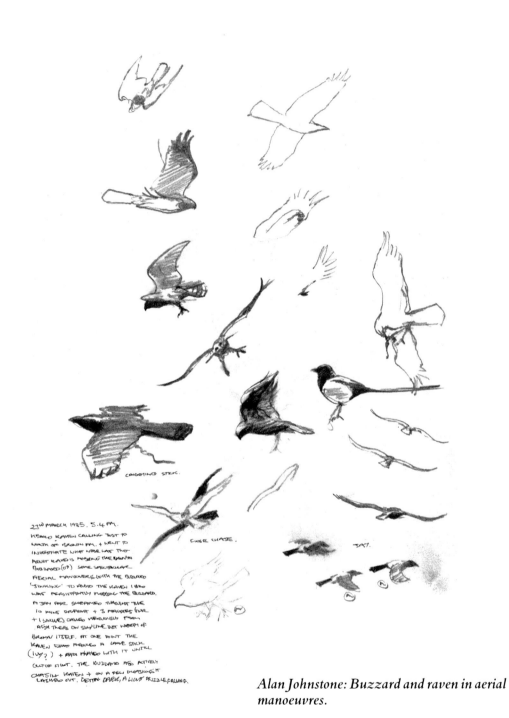

CRUISING STICK.

CLOSE CHASE.

JAY.

23rd MARCH 1985. 5.4 PM.

HEARD RAVEN CALLING JUST TO
NORTH OF BROWN FM. + WENT TO
INVESTIGATE WHAT NOISE WAS. TWO
ADULT RAVENS MOBBING THE BROWN
BUZZARD (♂) SOME SPECTACULAR
AERIAL MANOEUVRES (WITH THE BUZZARD
'SINKING' TO AVOID THE RAVEN) BIRD
WAS PERSISTENTLY MOBBING THE BUZZARD.

A JAY PAIR SCREAMED THROUGHOUT THE
10 MINS DRIFTING + 3 MAGPIES (IVER
+ 1 SINGLE) CALLED NERVOUSLY FROM
ASH TREES ON SKYLINE JUST NORTH OF
BROWN ITSELF. AT ONE POINT THE
RAVEN BIRD PICKED UP A LARGE STICK
(IVY?) + PLAYED WITH IT UNTIL
OUT OF SIGHT. THE BUZZARD ALSO ACTIVELY
CHASING RAVEN + ON A FEW OCCASIONS IT
LASHED OUT. GETTING DARK, A LIGHT DRIZZLE FALLING.

*Alan Johnstone: Buzzard and raven in aerial
manoeuvres.*

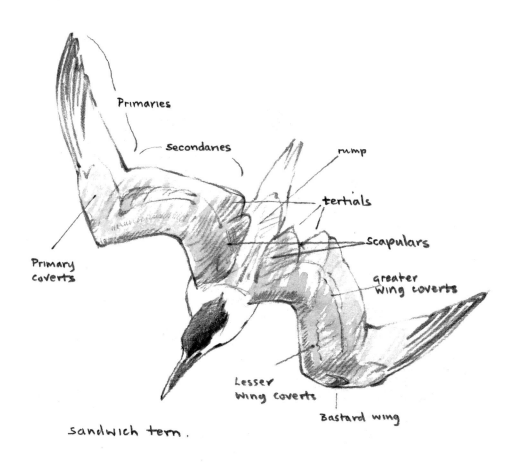

Primaries

Secondaries

rump

tertials

scapulars

greater
wing coverts

Primary
coverts

Lesser
wing coverts

Bastard wing

sandwich tern.

*John Busby: Wing feather groups; Sandwich
tern.*

wings, so it makes sense to draw both the leading edges first before the rest of the wings.
Above all, watch those 'hand' joints to see how much pressure they are exerting, and the
angle they give to the wing.

 In gliding birds, the humerus is long. So are the radius and ulna (which do not cross as in a
human arm). The fusion of wrist and what remains of hand and finger bones is
comparatively short. From each of these bones comes a group of backward-facing feathers;
primaries from the 'hand', secondaries from the radius/ulna, and tertiaries from the humerus.
These feathers, according to their length, give the width and shape to the wings. They are
strong with prominent shafts and a downward curve. This aerofoil section is further shaped
by the layers of smaller feathers which form the coverts on both surfaces of the wing. Because
the air has farther to go along the curved upper surface in the same time, it has to travel faster;
hence a reduction of pressure on top of the wing lifting the bird.

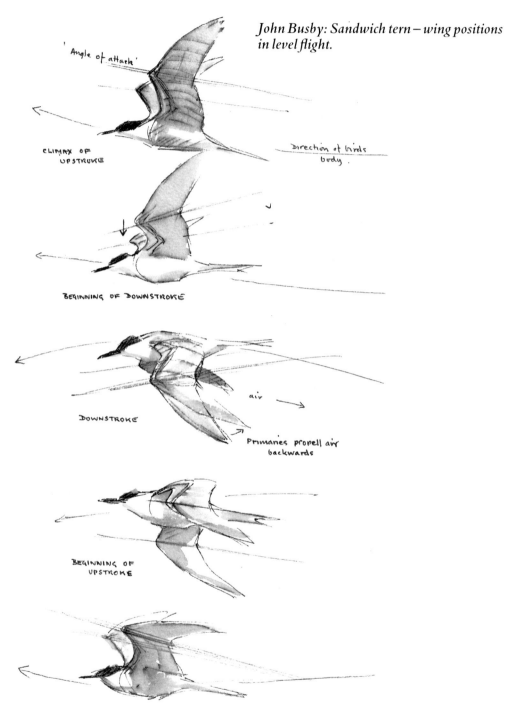

John Busby: Sandwich tern — wing positions in level flight.

'Angle of attack'

CLIMAX OF
UPSTROKE

Direction of birds
body.

BEGINNING OF DOWNSTROKE

DOWNSTROKE

air →

Primaries propell air
backwards

BEGINNING OF
UPSTROKE

UPSTROKE : WRISTS REACH CLIMAX BEFORE PRIMARY TIPS

THE PROPELL R TWIST ON THE 1st PRIMARY OF A PINK-FOOTED GOOSE

John Busby: The propeller twist on the first
primary of a pink-footed goose.

The primaries provide the driving power, pushing the air downwards and backwards. The vanes of the feathers are pressed firmly against the strong, flexible shafts of the preceding feathers, but allow air to slip through on the up-beat. The secondaries act as the main planing area, moving less than the wing-tips, maintaining level flight. The tertiaries extend this area and help to streamline the junction of wings and body. In small birds these last feathers are almost non-existent, the whole wing becoming the driving force with both primaries and secondaries longer than the much smaller wing bones. Instead of gliding, a small bird will missile itself through the air after a burst of power, wings closed, giving the characteristic undulating flight of many passerines. Italian Renaissance artists usually portrayed flying birds in the closed-wing position.

Though the 'hand' is reduced to three bones, the thumb still articulates and operates three feathers, known as the alula, or bastard wing. This is extended to help to control air flow when a bird is landing and near to stalling, or when a bird like a falcon is flying at speed with almost furled wings. On the leading edge there is a membrane containing tendons called the anterior patagium, stretching between the shoulder and the wrist, which gives the streamlined front edge to the wings, the elbow joints lying behind. (There is a similar membrane between elbow and body, but this is hidden by feathers.)

Covert feathers often show a distinct change of plumage pattern along their margins – a striking feature in some waders and ducks – so a line of the coverts can be drawn without counting individual feathers. I have always found R B Talbot Kelly's simplification of wing feather masses helpful to follow. He treated each group as a unit, with a line that did not stop the flow of movement. Apart from the first four or five primaries which may well be 'fingered' at their tips, the trailing edge of the wing quickly dissolves individual feathers into the general shape.

More subtle aspects of the planes and movements of the wings can be shown better by drawings than by written descriptions, and some of these will be revealed on later pages.

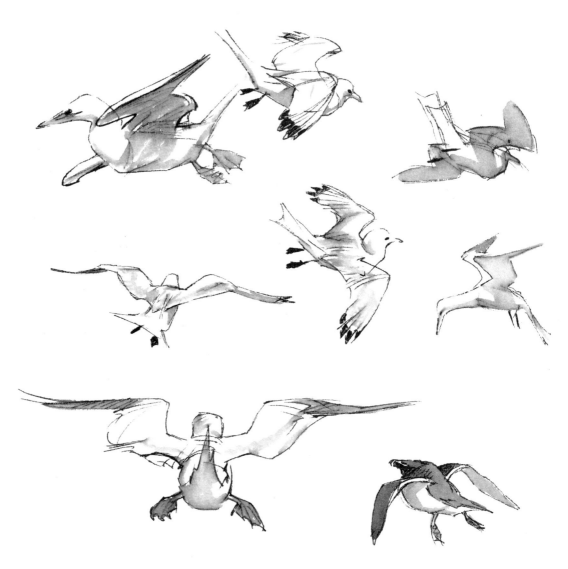

John Busby: Hang-gliders on the upcurrent over a cliff face: gannets and kittiwakes, and (right), jackdaws, which actively indulge in aerobatics in their family interactions.

A heavy bird like a gannet can also hang in the wind over a cliff edge where the updraught is strong enough to take its weight. There are so many birds at the Bass Rock where these were drawn that one has a constant stream of models taking up the same positions.

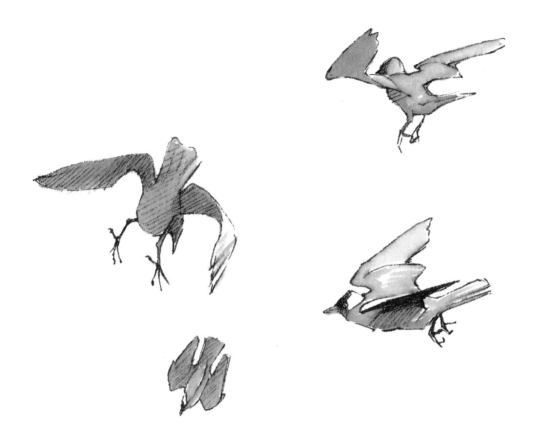

A flying bird invariably presents problems of foreshortening; both the body and the wings may be set at an angle to you. On land, a side-view bird is the easiest to draw, but wings coming towards you or partly hidden by the body of a flying bird are difficult to draw on the two-dimensional surface of the paper. A simple model cut out of folded paper can provide some of the answers to problems, and one can see clearly the consequences of wing angles, putting a paper bird through the wing-beat positions and looking at it from all angles.

Of course, the two wings of a bird are rarely identical in trim. Once airborne, every inch of a bird is in a state of constant adjustment to maintain momentum and equilibrium. As adjustments are made to air pressures and changes of direction, the wing shapes and angles will change, together with the shape and angle of the tail. Head and feet movements come into operation too, as the bird adjusts its weight to shift the centre of gravity; forward to increase speed, or backwards to gain more lift. Birds do not always have an easy time in the air. When the wind is strong, flying can be hazardous. On a seacliff one can marvel at the delicate buoyancy of kittiwakes wheeling in all the cross-currents of a buffeting wind, or hanging on drawn tight wings, head pulled back and legs dangling.

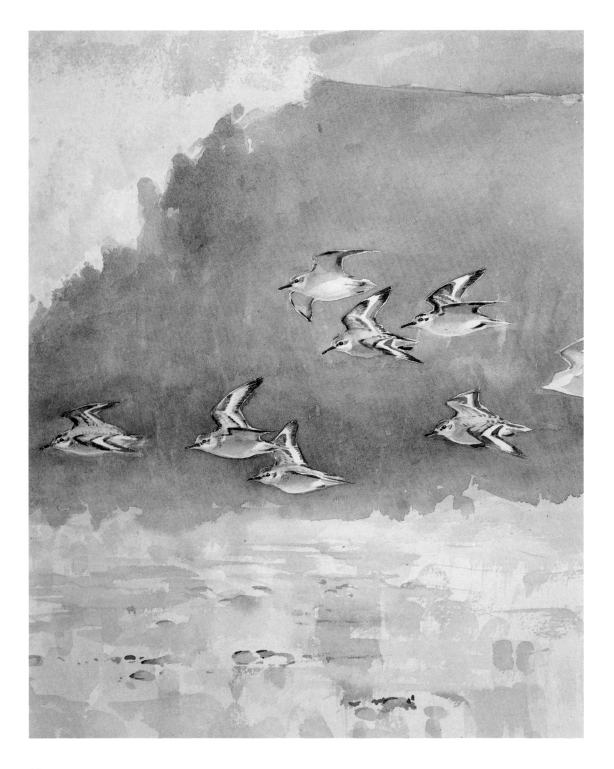

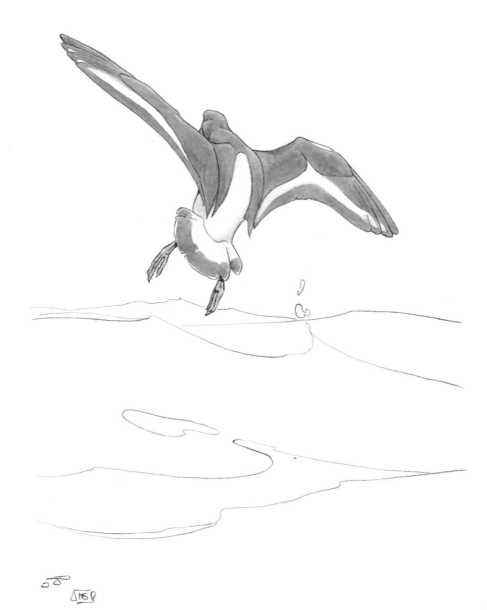

◀ *Peter Partington: Sanderlings and a breaking wave; watercolour.*

The repeated pattern of a flock of birds in similar positions adds to the sense of movement. The sanderlings are almost surfing on the air pushed forward by the great wave behind, the diagonal of the breaking wave increasing the visual momentum.

▲ *R B Talbot Kelly: Oystercatcher taking off.*

The bird has been wading in the sea and is turning to the right. The left wing is at full stretch on the down beat, the right more flexed and angled almost to a stall position to brake the bird round. Feet and head are reacting to the sideways thrust on the body.

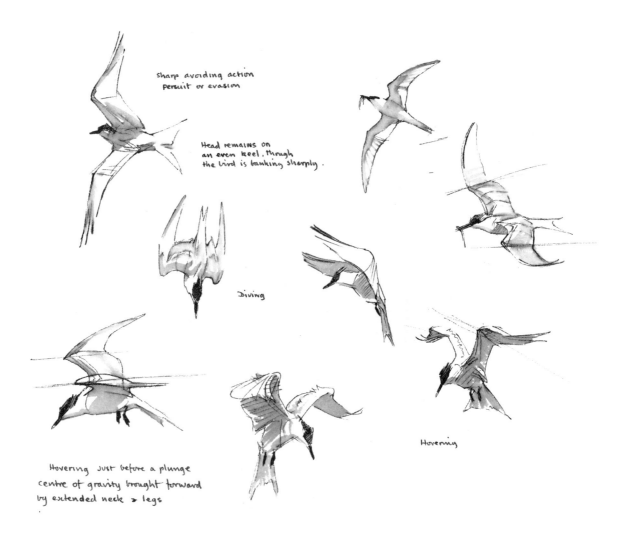

The following handwritten annotations appear within the illustration:

sharp avoiding action
persuit or evasion

Head remains on
an even keel, through
the bird is banking sharply.

Diving

Hovering

Hovering just before a plunge
centre of gravity brought forward
by extended neck & legs

▲ *John Busby: Flight actions of Sandwich terns.*

Sharp avoiding action; the head remains on an even keel although the bird is banking sharply to the left.

Diving; wings held close-furled until the last moment when they will be stretched backwards as the bird enters the water.

Hovering; terns can on occasions fly backwards, obtaining lift on the up-stroke with the wing angled backwards. The unstable air over the wings will lift the covert feathers on the top of the wing in this near stalling position. Just before a plunge the centre of gravity will be brought forward by extended neck and legs.

▶ *John Busby: A cut-out model can provide the answer to problems of foreshortening.*

A model can be held at different angles and in different lights to see how wing shadows might fall across the body.

100

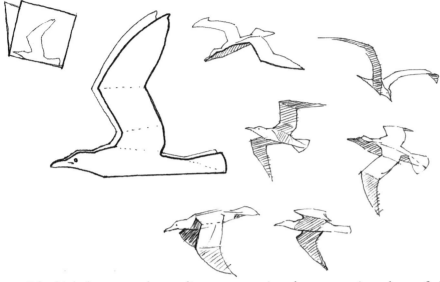

I find it helps me to draw a line representing the supporting plane of air on which the bird hangs. It can help too to put imaginary section lines across the wings to make sure of their camber. (This must be a throwback to my aeromodelling days.)

To draw first a bird's flight-path can help you to plot the changing positions of a circling gull for instance, and drawing flight positions in sequence is one of the best ways of understanding and seeing the changes and adjustments taking place.

Fast, powerful flight presents a great deal of bewildering movement, often too quick for the eye to follow, and difficult to reconstruct afterwards. It is probably best to respond to a gut feeling for the action. Pursuit, evasion and display will involve more than one bird, and curiously, it can be easier to convey action with two birds rather than one, as the space between them can increase the tension. Sharp, angular lines will show the extremes of wing action and the stress of the bird. Changes of direction, indicated by a shift of angle between head and body or tail, will add to the drama and help to point the eye across the spaces in the drawing.

Drawing flocks of birds in flight offers the dynamics of repeated pattern, especially the tight formations of flighting waders or ducks. These birds tend to fly in unison, the whole flock turning at the same time, and the 'vee' shapes of such birds add to a sense of movement. (See the flying ducks in the published sketchbooks of Charles Tunnicliffe.)

Less co-ordinated groups of flying birds can be difficult to compose well in a drawing as they are all probably moving in different planes and different directions. One needs a strong sense of the 'space' of one's flat page, and I will launch into that in the next chapter.

With practice and field experience, a feel for bird-flight will develop. You will need to rely on memory to a greater extent than before, and as in all bird drawing, if you can remember what the bird or birds were doing (the nature and purpose of their flight) then recalling what you saw is easier. The more you practise drawing from memory, the more you will find stored there – providing of course that you put in those essential and enjoyable hours of watching and wondering.

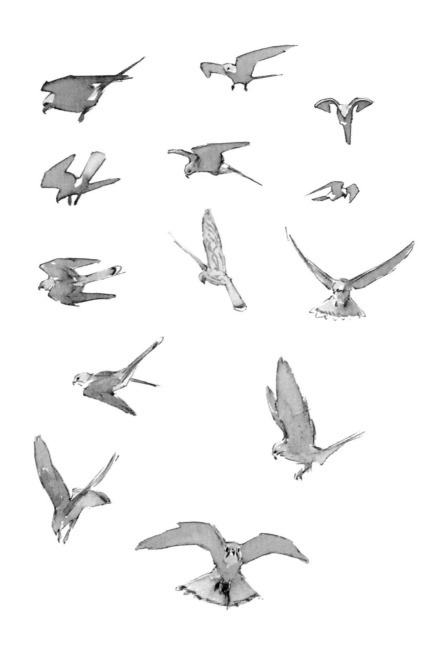

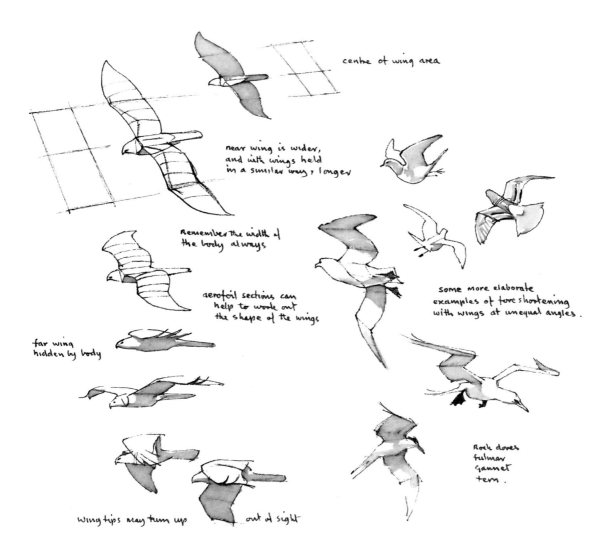

centre of wing area

near wing is wider, and with wings held in a similar way, longer

Remember the width of the body always

aerofoil sections can help to work out the shape of the wings

some more elaborate examples of foreshortening with wings at unequal angles.

far wing hidden by body

Rock doves
fulmar
gannet
tern.

wing tips may turn up out of sight

◀ John Busby: Hovering kestrel.

In contrast to the whirr of blurred wings which we see when a small bird takes to the air, the balancing of larger birds that hang in the wind is a joy to watch. The most familiar of these is probably the kestrel which can trim its wings so efficiently as to remain stationary even in a strong wind. Hovering requires exact adjustment of the planes and angles of the body to the direction and velocity of the wind, which is seldom constant. Once prey has been sighted,

the bird's head remains perfectly still. Can you tell from the drawings whether the bird is still, or in which direction it is moving?

▲ John Busby: Foreshortened wings.

103

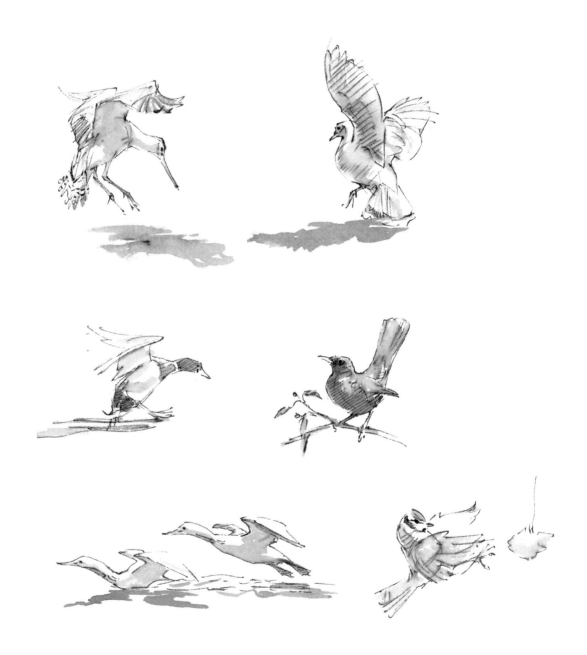

104

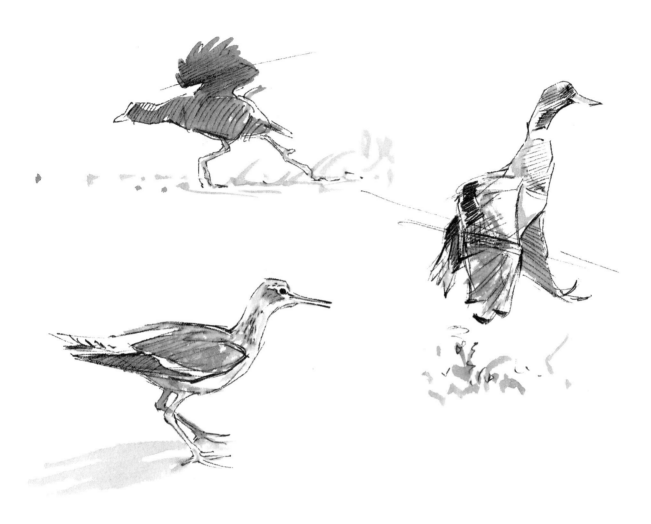

◀ *John Busby: Birds landing.*
 Bar-tailed godwit and pigeon, wings beating forwards, tail depressed, but head positions different. Blackbird landing, tail swinging high (to counter-balance the sudden stop?).
 Mallard foot-skiing on the water and red-throated divers belly-landing. Blue tit landing horizontally.

▲ *John Busby: Birds taking off.*
 Coot and mallard taking off – one running to gain air-speed, the other leaping upwards. Redshank showing all the signs of imminent departure – wrist joints of wings exposed, legs flexed and body lowered for a jump, neck stretched, and alarm calls given.

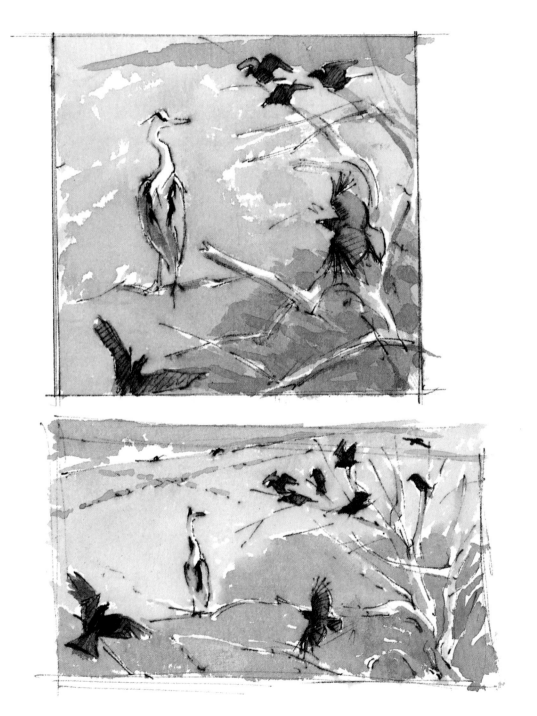

106

6: Birds on the Page

I N earlier chapters, I have suggested that there can be more to portraying a bird than
getting it bird-perfect. I have encouraged you to see birds in the context of their
surroundings, and to be aware of their movements and the space around them. If, in
your field sketches you regularly note the scale and placing of features in a bird's
environment, then you have already begun to think about the relationship of the various
elements to be included in your picture. Now, what can be done to communicate the events
you see by the way a drawing or a painting is composed?

Composition is a matter of controlling expressively all the elements in your picture. The
same birds, trees and sky transposed into the shapes, lines and colours of your picture can be
composed in many *different* ways, and according to where a bird is placed within the shape of
your picture, you can often say more about its ways than you can by the degree of finish.

Perhaps binoculars encourage us to centre a bird in our vision, and if one's purpose is to
make the bird a static object of scrutiny, then by all means place it right in the middle of a
picture, where it will remain immovable. More usually a bird's presence is unexpected and
fleeting; seen in a sequence of movements; merging perhaps with the shapes and patterns of
branches or the forms of rocks; among shadows and a variety of background colours. When

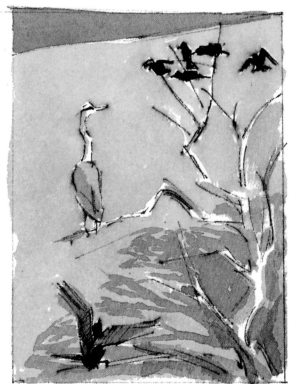

*John Busby: Compositional studies for a
painting of a heron surrounded by rooks.*

*I saw this heron land on a dead tree after
being harried in flight – both species were then
held in a balanced tension of threat and counter-
threat. I aimed to make the heron's head the
focal point in all three studies, as the bird
commanded the space round about it, keeping
the rooks at a respectful distance. The different
picture rectangles bring out different placings of
the birds, and rhythms of the trees. I kept the
heron exposed against the sunlit hillside, with
tree shadows adding to the threatening feeling of
the patterns of rooks and branches. The facing
away heron seems more vulnerable.*

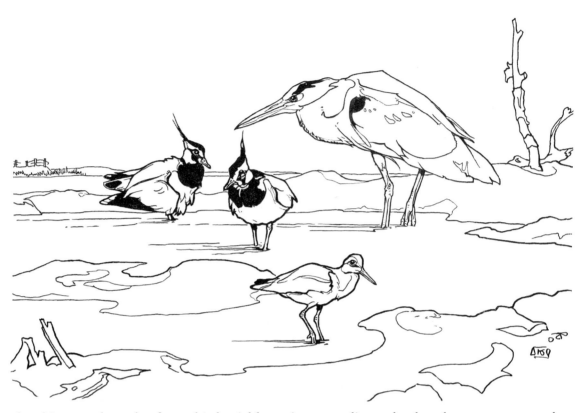

sketching, set the scale of your bird quickly against any adjacent landmarks, trees or ground patterns before it has time to fly away. This can be done with a few simplified lines, as I suggested in Chapter Two. Detailed study can follow after the bird has flown. There is then time at leisure to make drawings of as much of the environment as you need, remembering the bird's 'track' through what you are drawing. Concocted backgrounds round a finished bird are seldom convincing – they contain none of the surprises one sees in life, so forget the conventions of 'Bird Art', and link your bird strongly to time and place, and to the way a bird itself uses its surroundings. Search out the kind of placing that will convey the experience of what you saw.

Moments that are brief or surprising will need to be conveyed by less predictable composing on your page. The birds in your pictures should move into their surroundings without undue emphasis. Let a bird be well hidden if that is right for the occasion, without spotlighting it or fading away 'mere' background. How often do you see a sitting woodcock or a sleeping owl so immediately as many a 'portrait' would suggest? It would make more sense to draw the eye away from a hiding bird by stronger emphasis on other parts of the background. Background details offer as much variety of drawable material to enjoy as do the birds.

It is important to remember that whatever you are drawing, you are also forming the shapes outside your lines. So part of a sky for instance (what one can call a 'negative' space) becomes much more potent in the two-dimensions within a pictorial rectangle. Good design

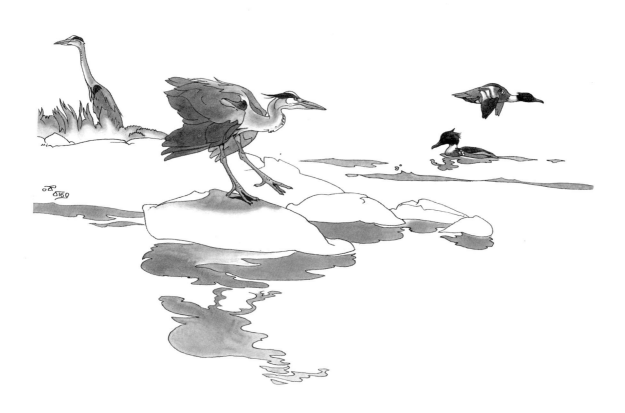

R B Talbot Kelly: Lapwings, heron and a green sandpiper: and herons with red-breasted mergansers.

The artist delighted in portraying such events. In his book The Way of Birds, *he says; "Every one of these drawings I have seen first in the field. In each case I have come back 'red hot' from the impression of them, and tried to draw what I felt as well as what I saw."*

In all his drawings you can see exactly what the birds are up to – a heron just landing; merganser just about to dive; lapwings pausing while bathing. Throughout there is great economy and discipline of line. (The drawing on the left appears in colour in The Way of Birds.)

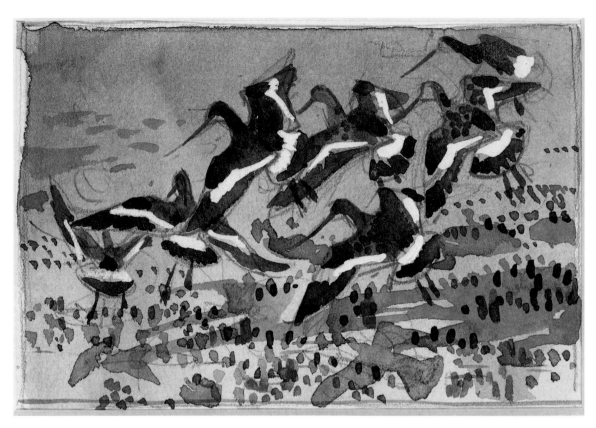

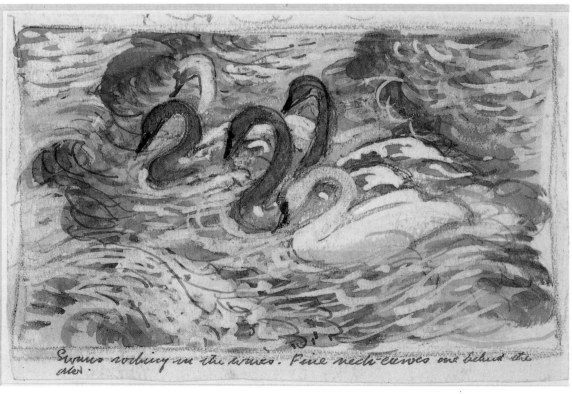

Swans rocking in the waves. Fine neck-curves one behind the other.

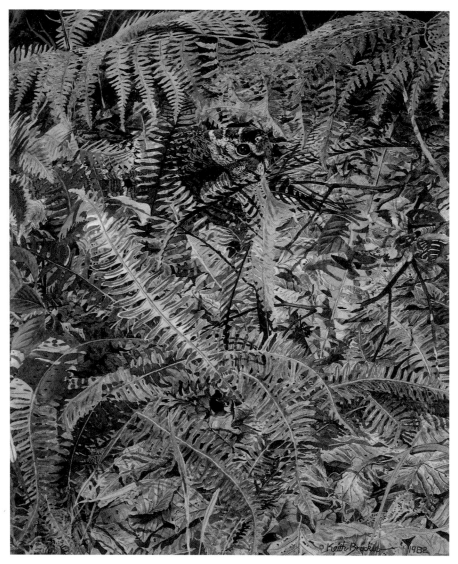

◀ *Charles Tunnicliffe: Tiny composition sketches for paintings of black-tailed godwits landing, and mute swans on a choppy mere. The artist made many hundreds of such preliminary testings of ideas for arrangement and colour in the course of his life. The repeated rhythms of wing patterns in the godwits and in the curves of the swans' necks, give a strong sense of movement to the pictures.*

▲ *Keith Brockie: Nesting woodcock; watercolour and acrylic.*

This is a portrait the bird might approve of, not spotlit as in many 'sporting pictures', but almost invisible.

Keith recalls, "I sat painting this confiding woodcock for two hours on three consecutive days. The strong light and shade gave the vegetation an abstract quality."

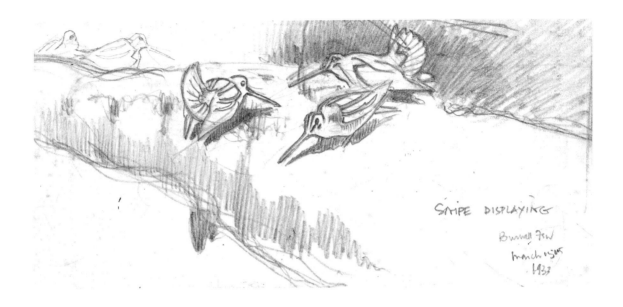

SNIPE DISPLAYING

Burwell Fen
march 1937

Eric Ennion: A group of snipe displaying.

The positions and attitudes of snipe are all important. The males are fanning their chestnut tails towards the female, while other snipe watch. The few lines and shading set the scene quickly, establishing the ground and the sunlight. All Ennion's compositions spring quite naturally from the groupings of birds he saw; nothing is ever forced.

depends on the patterns and balances that exist everywhere within the picture. The starting place is the shape of your page.

Compositional sketches can begin as quite small notes in your sketchbook, testing out the possibilities of alternative shapes of rectangle. One should not let the page size of the paper you are working on dictate the format, but begin with a positive outer shape and compose within it. In this way the forces of the shape's geometry can be used. This sounds more complicated than it is. Most of us have an instinctive sense of balance and arrangement and this is your best guide. The outer shape of your composition will generate energies leading into the picture. Some artists may do the opposite, beginning with the main subject and working outwards, finally deciding where to put the boundary edges of the picture. This often leads to weakening energies dispersing from the subject, and to what I might call a 'one-way picture', where your eyes go straight to the subject and stay there. A good composition will keep your eyes moving, linking still moments in such a way that your eyes travel on, and the picture renews itself, able to reveal other levels of association and meaning.

Artists seldom take up the first ideas that come into their heads. Let first thoughts on composition grow and develop, and play around with alternatives, gradually bringing one's intentions into focus by rearrangement and the elimination of all that is inessential.★

★ A most revealing series of compositional sketches is published under the title, *The Two Worlds of Andy Wyeth* (Houghton Mifflin Co, NY), where the truly poetic vision of this fine artist is traced through his sketches to his finished work.

Michael Warren: Composition notes for a calendar design for the RSPB showing woodland birds – woodcock, chiffchaff, and tawny owls.

The time of year is March when primroses and willow and ash buds will be appearing. Background details, if not drawn on the spot, should be checked carefully for seasonal rightness.

Sanderlings on a breakwater: Sept 84, Mass, USA.

John Busby.

The choice of where to use details or emphases depends on where these moments come within the composition. It would be unthinkable for an artist to complete a drawing of a bird, however accurate and ornithologically right, and then place it unaltered within a picture. A different placing of the same bird would call up different emphatic moments within it. These moments come from the initial placing and not the other way round. A stooping falcon, for instance, will not be more convincing in its speed for having all its tail feathers counted, but by how well your eyes are led forward through its body and across the 'charged' space before it.

With flying birds in particular, it will increase a sense of movement to project the main rhythmic lines of the birds, and make some focal point ahead which will pull the birds towards it. All the shapes you use in a picture are to a large extent pointers to other parts of the picture, and when this energy is picked up the eyes can jump across space easily. Composing the spaces of, say, a milling seabird colony can be more of a challenge than drawing the birds!

Colour and tone can also be used in a rhythmic way, as your eyes will move towards the brightest moment, say, of red, through the more muted areas of similar colour, as they will towards the strongest contrasts of tone or even the sharpest edges – any accents which pull the eyes. Everything you put in a picture affects everything else in it. Increase the dark tones and the light ones shine more brilliantly; surround a muted yellow with cool greys and blues and it will glow more than the brightest yellow next to reds and browns; one line will throw and catch another like a player in a ball game. It is all an exciting juggling game with your sensibilities and imagination.

John Busby 88 Bass Rock.

◀ *John Busby: Sanderlings and gulls.*

Contrasts, both of species and behaviour, can be a source of much interest and at times amusement, giving rise to unusual compositional ideas. Here is a scene on the end of a breakwater at Wilmslow in Massachusetts. As each wave broke, a party of sanderlings ran in unison up the weed-covered stonework, then turned and ran back again as the water receded; a performance repeated every five or six seconds. The gulls – a herring and a great black-back –

sat sedately above the reach of the water. It was a September afternoon of dark sea and strong sunlight.

▲ *John Busby: Gannets and well-grown chicks on the Bass Rock.*

The Bass is a teeming, milling throng of birds, but one can convey some of this with a representative few. The directions of the bird's bodies or pointing beaks, as well as lines on the rocks or the sea are all part of the interlacing linear structure of the drawing.

115

David G Measures: A drawing of a sitting hen pheasant on a wood bank beneath a field maple.

Compare with the illustration opposite.

To enjoy a picture our eyes need variety – tone and colour changes and relationships, variations of pace, the play of shapes and patterns. To engage the mind as well, evidence of the artist's thoughts and feelings are essential. I hope these qualities are latent in all the field sketches chosen for this book, because even in a drawing of a single bird there is need for variety of emphasis, from strong definition to the delicacy of the merest suggestion. A flat, mechanical line will kill the form within any shape, as it will in music or the spoken word, while a good line will make it live.

It is really beyond the scope of a book entitled *Drawing Birds*, to go very far into the complexities of painting. I have tried to avoid a definition of drawing, taking it above all to mean the most direct means of expression in any medium – the way of 'drawing out' what is in the mind and eye of the artist.

Colour is a part of this too, a very personal language when used pictorially. It takes many years to see colour with an artist's eye. Indeed, though nearly all of us could detect a musical discord without any training, very few people could spot a colour discord or know when

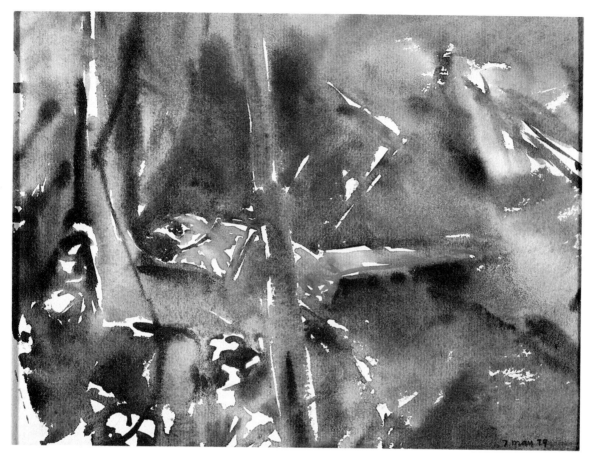

David G Measures: A watercolour of the same sitting pheasant. The change of medium leads to a different way of seeing, muted colours adding a new dimension of stillness to this moment shared with the bird.

colours had a close relationship similar to a musical chord. We blandly accept that if the colours we see exist in nature they must be safe to put in a picture. I sometimes tell my shocked students that colour is too important to be left to nature – meaning that it is far more important that colours should be right to each other in the picture. 'Accurate' or local colour, that of the subject seen in isolation and matched on your palette, is no guarantee of truth. A laboratory bird is impossible in the wild. Never use a colour that causes a disaster to the rest.

Colour is the most transient and changeable of all visual experiences, dependent entirely on the quality of light. The red of a robin against the snow is not the same as the red breast barely visible beneath the holly bush, and has changed again when the bird hops out into full sunlight. Learn to see plumage as it is, not as your brain tells you it ought to be.

One very simple tip for using colour in field sketching is to choose only a few colours to work with and not to copy literally the range of colour you see. You need at least one colour that is warm (for example, sienna or light red) and one that is cold (cobalt, Antwerp or Prussian blue). The basis of lively colour is the play between warm and cold colours.

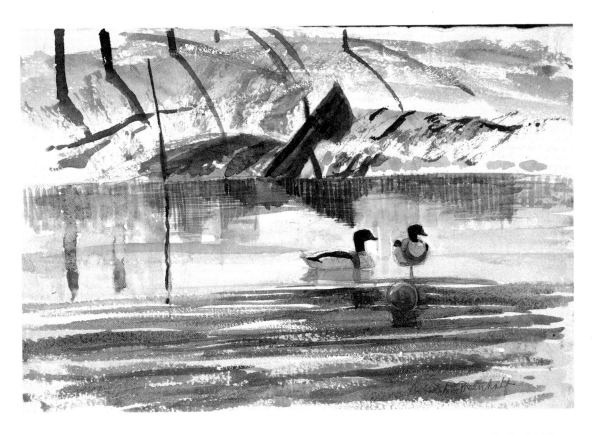

Robert Greenhalf: Shelduck on the river near Rye.

A beautiful still composition, but with an alertness in the birds and a tension induced by the angular, dark diagonal shape on the far bank, with its shadow pointing at the birds. The colours create a feeling of cool afternoon light reflecting strongly from the mudbank and water.

I tend to use watercolour as the quickest medium for field colour notes, using a sketchbook with good enough paper to take water without buckling, but other artists use coloured crayons most effectively. My most used colours are Payne's grey (a bluish black), raw sienna, light red, Antwerp blue, lemon yellow (the Winsor and Newton variety, which is very muted and opaque), with brighter colours held in reserve. The duller the colours the easier they are to handle, and brightness, as I suggested earlier, is induced rather than laid on with a trowel. Begin with the largest areas, leaving the points of greatest brightness and strongest tones until last, although in your sketches, know where they are to be. Place all accents carefully early on. Unity in a painting is worth fighting for – it won't come easily.

Finally; be true to your own observations in all matters. Never devalue your field sketches by comparing them unfavourably with the finished work of others. Authentic records of moments seen have, I believe, more value than the most artful reconstruction, because the experience behind them is genuine. In any finished work try to keep to the spirit of the

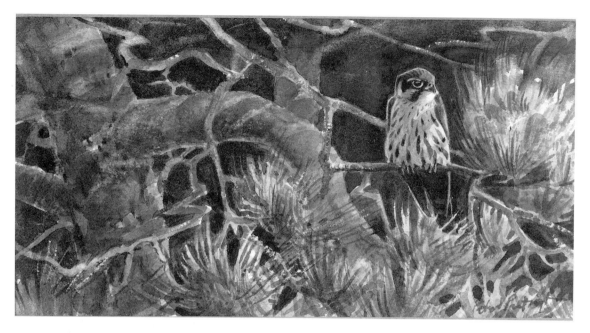

Peter Partington: Young hobby; watercolour.
 The falcon, allowed to look small against the large area of pine, is the only vertical in a network of diagonals – branches and angles of light. That it is also looking out of the picture adds to the feeling of spaciousness.

sketches. This is by no means easy, and almost impossible if you try to 'freeze-dry' a sketch exactly. Use sketches as a guide, but redraw from memory stimulated by your field work, carefully composing the energies in your more considered drawing. If it loses the life of the bird in the process, tear it up and start again – and again.

Keep going in spite of early 'flops'. It may take half a lifetime to fly with the birds. The more you do, the better you will become, *especially* if you enlarge your observation to include all manner of other things in the scope of your drawing.

Be adventurous, both in the field and in the studio. There are new understandings of bird behaviour and ecology to be expressed today, and the portrayal of birds is in great need of fresh vision to match. With so much of our wildlife under threat, the more we can cement our emotional links with nature in a deep, appreciative, but unsentimental way, the more it will strengthen the public will for conservation.

Artists have a lot of challenging work to do in presenting the reality of nature as one of the inspiring and urgent themes of our day.

Contributing artists

David Boys

Born in 1960, in Kent. Studied illustration at Maidstone College of Art and the Royal College London, graduating 1985. Now freelancing. Published *The Greenhouse* – lithos of the aviary at the Royal College. Made an extensive field sketching tour by cycle of the Western and Northern Isles of Scotland in the summer of 1985. Since then working with design unit at London Zoo.

Keith Brockie

Born East Lothian 1955. Interest in birds developed after a move to Fife at age of 13. Studied at Dundee College of Art; Diploma in Illustration and Printmaking 1978. Works as a freelance illustrator. He is an experienced naturalist, falconer and bird ringer, and has accompanied expeditions to Lappland and the Middle East.

John Busby
RSW

Born Yorkshire 1928. Spent early years in Wharfedale, close to Ilkley moor. Studied at Leeds and Edinburgh Colleges of Art, and travelled in France and Italy. Has taught drawing and painting at ECA since 1956. Founder member Society of Wildlife Artists, Past President Society of Scottish Artists and member of Royal Scottish Watercolour Society. Has exhibited widely in Scotland and England, and also in USA. Represented in *Animals in Art* exhibition in Toronto, and Scottish Arts Council tours, also in several municipal galleries and private collections.

Alexander Campbell
MA, RSA, RSW

Born Edinburgh 1932. Studied at Edinburgh College of Art and Edinburgh University, and is now Senior Lecturer at ECA. Animals and birds are occasional subjects in the range of this artist's work, always they show his affinity and feeling for their character. He has exhibited widely in Scotland and is represented in most collections there. Recent one-man shows have been at The Mercury Galleries in London and Edinburgh.

Joseph Crawhall	1861–1913. Born in Northumberland. Already an impressive artist at age of 14. Studied at Kings College in London and later in Paris at the studio of Aimé Morot. Closely associated with Glasgow artists, E A Walton and James Guthrie and others of the 'Glasgow Boys', though of a very retiring disposition, known to his friends as 'the great silence'. He was a perfectionist in his art, destroying anything that did not meet his own exacting standard. Frequently visited north Africa to paint, moving finally to Yorkshire. Many of his finest paintings are in the Burrell Collection, Glasgow Museum and Art Galleries.
Eric Ennion	1900–1981. Doctor of medicine, naturalist, artist and educator. Left medicine in 1945 to run Flatford Mill Field Centre. In 1950 opened his own bird observatory and field centre on the coast of Northumberland, moving to Wiltshire ten years later, where he held an annual drawing course for bird artists. He wrote and illustrated many articles and books, broadcast regularly, and exhibited paintings. He was foremost in setting up the SWLA, whose first exhibition was held in London in 1964.
Jon Fjeldså	Born in Bodø in northern Norway in 1942. Studied zoology in Bergen, and since 1971, Curator of Ornithology at the Zoological Museum of Copenhagen, Denmark. Has undertaken long periods of field study in Norway, Iceland, Australia and South America. Publications include numerous school books on biology and illustrations to *Manual of Andean Birds* 1986.
Jack B Flemming MSIAD, RSW, HRGI	1912–1986. Studied at Glasgow School of Art; interior designer in Glasgow 1935–1940; merchant navy during the war; Lecturer to Senior Registrar, Glasgow School of Art 1945–1977; freelance illustrator with Professor Meiklejohn and the *Glasgow Herald* 1954–1973, continued the bird column to 1976.
Robert Gillmor	Born in Reading 1936, the grandson of the artist A W Seaby. Studied at Reading University and taught at Leighton Park School before going freelance as an illustrator. *A Study of Blackbirds* by

David Snow, began a continuing list of
distinguished book illustrations, contributions to
magazines and work for ornithological bodies.
He has served on the council of the BTO, BOU
and RSPB and is a Founder member and now
Chairman of SWLA and has done much to
promote exhibitions of wildlife art. He has
exhibited paintings and prints in both Kenya and
the USA.

Robert Greenhalf

Born in Sussex 1950. Studied at Eastbourne and
Maidstone Colleges of Art. His main medium is
etching, particularly multi-coloured prints from a
single copper plate. He has exhibited widely in
England and Wales, and also in Switzerland and
the USA. He is a member of the SWLA and the
Royal Society of British Artists. Two of his
illustrations appear in *Flights of Imagination*, an
anthology of bird poetry.

Alan Johnstone

Born in 1959. Trained as a taxidermist at Glasgow
Museum. Won the *British Birds* R A Richardson
award in 1979, and attended Eric Ennion's last
drawing course at Weyhill. Worked as an RSPB
warden before continuing art studies at Dyfed
College of Art, qualifying with distinction in
wildlife illustration in 1985. Currently working as
graphic designer/taxidermist for Luxemburg
State Museum of Natural History.

George Jones

Gained Diploma in Wildlife Illustration at Dyfed
College of Art in 1984. At present working on
Skomer Island National Nature Reserve as
Assistant Warden.

Lars Jonsson

Born in 1952 and grew up in Stockholm. Drew
and painted from an early age, exhibiting at the
National Museum of Natural History at the age of
15. A self-taught and very gifted artist, now
exhibiting in Sweden, Britain and the USA.
Author and illustrator of five field handbooks on
the birds of Europe, published in seven countries.
In 1983 he published a beautiful account of life on
a shoal of sand called *Bird Island* [Croom Helm].
His painting of a gyrfalcon was used on the 50
Kroner stamp in 1982. He has also published
valuable work on the field identification of waders

and of warblers. In the USA he has conducted seminars on bird painting, and features in *Wildlife Painting* by Susan Rayfield [Watson Guptill, 1985].

Richard Kemp

Born in 1960. Studied printed textiles at West Sussex College of Design, 1977–1981. Selected to exhibit at 'Texprint 81', by the Design Council, and has designed for the RSPB. At present full-time graphic artist at the Wildfowl Trust centre at Arundel.

David Koster

Began drawing birds at age of nine, fired by A W Seaby's paintings in Kirkman and Jourdain's *British Birds*. Studied at the Slade School of Fine Art, illustrating *Down to Earth* with 17 wood engravings while still a student. Lecturer at Medway College of Design. Founder member SWLA. Lives in Folkestone, where his studio is equipped with litho and etching presses for producing limited edition prints. Recently illustrated *Fellow Mortals*, an anthology of animal verse chosen by Roy Fuller and published in support of the World Wildlife Fund.

Gwyneth Leach

Born Philadelphia, USA 1959. Studied University of Pennsylvania, graduating with distinction in anthropology and French. Awarded Thouron Fellowship to study painting and attended Edinburgh College of Art, 1980–84 gaining BA, and Post Graduate Scholarship 1985.

Clare Walker Leslie

Professional artist, naturalist and teacher, living in Vermont and Cambridge, Massachusetts. She has developed courses and workshops throughout New England in nature drawings, and is the author of several books on this subject.

Bruno Liljefors

1860–1939. Born Uppsala, Sweden. From early childhood he had a "peculiar and strong affection for watching wild animals appear out of doors", and for drawing them. He studied at the Academy of Arts in Stockholm but left to return to wildlife painting. He visited and studied with other artists in Germany and France and was a contemporary and friend of Anders Zorn. Returning to Sweden he devoted his artistry to painting wildlife, and is the acknowledged Great Master of that genre.

Most of his work is in the Thielska Gallery and the National Museum in Stockholm, and in the Gothenburg Art Gallery, or in private collections in Scandinavia.

Mick Manning

Born 1959, grew up in West Yorkshire. Greatly influenced as a budding artist and naturalist by the book *Tracks* by Ennion and Tinbergen. Studied graphic design at Newcastle Polytechnic, and is currently taking an MA in Natural History Illustration at the Royal College of Art. He has undertaken freelance illustration commissions for the Northumberland National Park and OUP.

Charlotte Mathews

Born in Sussex 1965. Interested in wildlife from an early age. Studied at Eastbourne College of Art, and at Dyfed College of Art doing wildlife illustration, graduating in 1986.

David G Measures

Born in Warwickshire, 1937. Studied at mid-Warwickshire School of Art and at the Slade School of Fine Art. He now teaches in the Fine Art department of Nottingham Polytechnic, and lives at Southwell. He is a devoted field naturalist, and all his drawing and painting is done in the field. He is interested in all forms of nature, particularly butterflies, which were the subject of his *Bright Wings Of Summer*, and *Watching Butterflies*. A selection of his field sketchbooks was toured by the Arts Council in 1984, and he co-ordinated an exhibition for York Festival in 1980 called 'Artist Naturalists'. In 1973 he appeared in 'David's Meadow' – one of the television series in 'Bellamy's Britain'.

Janet Melrose

Born 1964. Studied drawing and painting at Edinburgh College of Art, graduating 1986. She has made many powerful paintings of landscape and animals, including several of wild animals and birds in captivity.

Killian Mullarney

Born Dublin, 1958. All the Mullarney children were encouraged to draw and paint by their parents from an early age. For Killian, drawing birds was a natural consequence of the time he spent watching them. He worked as a commercial artist for seven years before going freelance in 1985. He is keenly interested in the

finer points of bird identification, and has served on the Irish Rare Birds Committee since 1980.

Peter Partington

Born in Cambridge, 1941. Fascinated by birds since boyhood in Dorset. Studied at Bournemouth and Hornsey Colleges of Art; now lectures in London. Began exhibiting abstract paintings but has since returned to his interest in wildlife for subject matter. He has exhibited widely in the south of England and also in W Germany. Contributed to *Flights of Imagination*; [Blandford Press 1982], an anthology of bird poems. Currently working on his own anthology.

J A Shepherd

1867–1953. Illustrator and cartoonist. He drew regularly for *The Strand Magazine*, *The Illustrated London News* and *Punch*, and illustrated many books; notably *The Bodley Head Natural History* and *Idlings in Arcadia*, by E D Cumming; *Songs of the Birds*, by W Garstang; and *Concerning Animals and Other Matters* by E H Aitken.

John Paige

Lifelong interest in natural history, especially birds. After service in the regular army, and brief period as national park warden in Uganda, took Dip AD in graphic design at Birmingham. He and his wife Jane run the Old Brewery Studios at their home in Kings Cliffe, Peterborough. Here they do their own work and organise courses in many aspects of art.

Chloe Talbot Kelly

Born Hampstead, 1927. Began studying in the bird room of the British Museum of Natural History at the age of 17. Has lived and worked in Africa, Australia and New Zealand, illustrating several handbooks of the birds of these and other countries and her own *Handguide to the Birds of New Zealand*. She is a Founder Member of the SWLA, and was represented at the Royal Ontario Museum *Animals in Art* exhibition in 1975.

R B Talbot Kelly

1896–1971. Born in Birkenhead. Distinguished military career during and after the first World War. Became Art Master at Rugby School in 1929, retiring 1966. During Second World War was chief instructor at the War Office School of Camouflage. Elected RI in 1926, and was Founder

Member SWLA. Design Consultant for the Pavilion of Natural Sciences at the Festival of Britain 1951, and designed displays for Uganda's first Museum of Natural History, and for Warwick County Museum and Cambridge University Museum of Zoology. He exhibited regularly at the RA and RI, the Paris Salon, and at the Tryon and Moorland Galleries. He was represented at the ROM *Animals in Art* exhibition.

Michael Warren

Born 1938. Studied at Wolverhampton College of Art. Began full time painting in 1972: regular exhibitions at the Moorland Gallery, London; also at Battaglia Gallery, New York. Produced a set of British Bird stamps in 1980, and Audubon Conservation stamps 1985. His first book, *Shorelines* was published in 1984.

Donald Watson

Ornithologist and professional artist, well known for his paintings of south-west Scotland, and an authority on moorland birds and birds of prey. Author and illustrator of *Birds of Moor and Mountain* [Scottish Academic Press, 1972]; *The Hen Harrier* [Poyser, 1977]; and illustrator of *The Oxford Book of Birds* [Oxford University Press, 1964] and *The Peregrine Falcon* [Poyser, 1983]. Contributed to *Birds in Scotland* [Poyser, 1986].

Bibliography

Here is a short selection of books of particular interest to bird artists:
On the work of Charles F Tunnicliffe:
 Portrait of a Country Artist: Ian Niall; Gollancz, 1980
 A Sketchbook of Birds: Ian Niall; Gollancz, 1979
 Sketches of Birdlife: Robert Gillmor; Gollancz, 1981
 Tunnicliffe's Birds: [Measured dead bird studies]; Noel Cusa; Gollancz, 1984
 Shorelands Summer Diary (reprint); Clive Holloway, 1985
 Tunnicliffe's Bird Life: Noel Cusa; Clive Holloway, 1985
George Lodge, artist/naturalist: edited by John Savory; Croom Helm, 1986
Crawhall in the Burrell Collection: Glasgow Art Galleries, 1953
The Living Birds of Eric Ennion: John Busby; Gollancz, 1982
Keith Brockie's Wildlife sketchbook: Dent, 1982
One Man's Island: Keith Brockie; Dent, 1984
Richard Bell's Britain: Collins, 1981
Wings and Seasons: Gunnar Brüsewitz; Croom Helm, 1980
Field guides: Lars Jonsson; vol 1 to 4 Penguin, 1978, 1979; vol 5 Croom Helm, 1982
Bird Island: Lars Jonsson; Croom Helm, 1983
Guide to the Young of European Precocial birds: Jon Fjêldså; Skarv, 1977
Charles F Tunnicliffe. The Composition Drawings: catalogue with introduction by Robert Gillmor. The Tryon and Moorland Gallery, 1986
Janet Marsh's Nature Diary: Collins
Bright Wings of Summer: David G Measures; Cassell, 1976 [These are butterfly paintings]
Second Nature: Edited by Richard Mabey; Jonathon Cape, 1984
Shorelines: Michael Warren; Hodder & Stoughton, 1984
The Countryside in Winter: Brian Jackman, illustrated by Bruce Pearson; Hutchinson, 1985
Black Robin Country: David Cemmick and Dick Veitch; Hodder & Stoughton, 1985
Birds of Moor and Mountain: Donald Watson; Scottish Academic Press, 1972
The Hen Harrier: Donald Watson; Poyser, 1977
Robert Gillmor: Illustrations to many books and articles, including *Herons of the World*, London Editions, 1978
Observations of Wildlife: Sir Peter Scott; Phaidon, 1980
Edward Lear's Birds: Susan Hyman; Weidenfeld & Nicholson, 1980
The Book of Birds: A M Lysaght; Phaidon, 1975
The Art of Natural History: S Peter Dance; Country Life, 1978
Twentieth Century Wildlife Artists: Nicholas Hammond; Christopher Helm, 1986

Books by or on North American and other Artists:
Nature Drawing, a Tool for Learning: Clare Walker Leslie; Prentice Hall, 1983
The Art of Field Sketching: Clare Walker Leslie; Prentice Hall, 1984

Studies and Sketches of a Bird Painter: Raymond Ching; Lansdown Editions, 1981
Wildlife Artists at Work: Patricia Van Gelder; Watson-Guptill, 1982
American Wildlife Painting: Martina R Norelli; Watson-Guptill, 1975; Phaidon, 1976
Wildlife Painting, Techniques of Modern Masters: Susan Rayfeld; Watson-Guptill, 1985
The Art of Bob Kuhn: North Light Publishing Inc, 1973
The Two Worlds of Andrew Wyeth: Thomas Hoving; Houghton Mifflin Co, 1978 [About people and places; not birds]
The Art of Robert Bateman: Ramsay Derry; Viking/Madison Press, 1981
The World of Robert Bateman: Ramsay Derry; Viking/Madison Press Book, 1985
Louis Agassiz Fuertes and the singular beauty of birds: Frederick George Marcham; Harper and Row, 1971
A Celebration of Birds: The Life and Work of Louis Agassiz Fuertes: Robert McCracken Peck, Collins, 1983
The Original Water-color paintings by John James Audubon: Michael Joseph, 1966, reprinted in one volume since
Bruno Liljefors: Allan Ellenius; Bokforlaget Carmina, 1981 [no English version available]

Books to look out for in second-hand bookshops:
The Way of Birds: R B Talbot Kelly; Collins, 1937
Birds of The Sea: R M Lockley, illustrated by Talbot Kelly; King Penguin, 1945
Bird Life and the Painter: R B Talbot Kelly; Studio Publ., 1955
By E A R Ennion:
 The British Bird: OUP, 1943
 Adventurer's Fen: Herbert Jenkins, 1949
 The Story of Migration: Harrap, 1947
 The Lapwing: Methuen, 1949
 Tracks: [Ennion and Tinbergen] OUP, 1967
 The House on the Shore: Routledge & Kegan Paul, 1959
Bird Portraiture: C F Tunnicliffe; Studio, 1949 [Many other books illustrated by this artist]
How to Draw Birds: Raymond Shepherd; Studio, 1949
Drawing at the Zoo: Raymond Shepherd; Studio, 1949
The Bodley Head Natural History, Vols 1 & 2; J A Shepherd; Bodley Head, 1913
A Frolic Round the Zoo: J A Shepherd; Bodley Head, 1926
The Birds of the Air: Allen W Seaby; A & C Black, 1931
British Birds: Kirkman and Jourdain, Th Nelson, 1910 reprinted 1942 and subsequently
Drawing Birds: Maurice Wilson; Studio, 1965
Drawing Animals: Maurice Wilson; Studio
Bruno Liljefors, an Appreciation: Dr Russow; C E Fritze Ltd, 1929
By Peter Scott: *Morning Flight* and *Wild Chorus*; Country Life 1935 & 1938 with numerous reprints
Joseph Crawhall: Adrian Bury; Charles Skilton Ltd, 1958